A CREATIVE GUIDE TO

EXPLORING
YOUR LIFE

of related interest

Inner Journeying Through Art-Journaling
Learning to See and Record your Life as a Work of Art
Marianne Hieb
ISBN 978 1 84310 794 1

Who's Who of the Brain
A Guide to Its Inhabitants, Where They Live and What They do
Kenneth Nunn, Tanya Hanstock and Bryan Lask
Illustrated by Linn Iril Hjelseth
ISBN 978 1 84310 470 4

Writing Works
A Resource Handbook for Therapeutic Writing Workshops and Activities
Edited by Gillie Bolton, Victoria Field and Kate Thompson
Foreword by Blake Morrison
ISBN 978 1 84310 468 1

Grief Unseen
Healing Pregnancy Loss through the Arts
Laura Seftel
Foreword by Sherokee Ilse
ISBN 978 1 84310 805 4

Drawing from Within
Using Art to Treat Eating Disorders
Lisa D. Hinz
ISBN 978 1 84310 822 1

A CREATIVE GUIDE TO
EXPLORING
YOUR LIFE

Self-Reflection Using Photography, Art, and Writing

GRAHAM GORDON RAMSAY
AND HOLLY BARLOW SWEET

Jessica Kingsley *Publishers*
London and Philadelphia

First published in 2009
by Jessica Kingsley Publishers
116 Pentonville Road
London N1 9JB, UK
and
400 Market Street, Suite 400
Philadelphia, PA 19106, USA

www.jkp.com

Copyright © Graham Gordon Ramsay and Holly Barlow Sweet 2009
Printed digitally since 2012

Library of Congress Cataloging in Publication Data
Ramsay, Graham Gordon.
 A creative guide to exploring your life : self-reflection using photography, art, and writing /
Graham Gordon Ramsay and Holly Barlow Sweet.
 p. cm.
 Includes bibliographical references.
 ISBN 978-1-84310-892-4 (pbk. : alk. paper) 1. Self. 2. Photography. 3. Art. 4.
Authorship. I. Sweet, Holly Barlow. II. Title.
 BF697.R33 2009
 158.1--dc22
 2008019368

British Library Cataloguing in Publication Data
A CIP catalogue record for this book is available from the British Library

ISBN 978 1 84310 892 4

Contents

ACKNOWLEDGEMENTS 7

PREFACE: THE BIRTH OF THIS BOOK 9

INTRODUCTION: HOW TO USE THIS BOOK 13

CHAPTER 1 The Journey of Self-Discovery 17

CHAPTER 2 The Value of Self-Expression 28

CHAPTER 3 Turning Points and Key People 38

CHAPTER 4 Gender and Self 60

CHAPTER 5 Race and Ethnicity 77

CHAPTER 6 Self in Historical Context 95

CHAPTER 7 Meaning in Our Lives 111

CHAPTER 8 Alternative Views of Self 127

CHAPTER 9 Self in the Future 144

CHAPTER 10 Creating a Mixed-Media Portrayal of Self 160

CHAPTER 11 Final Reflections 172

APPENDIX A: A GUIDE FOR INSTRUCTORS
AND GROUP FACILITATORS 177

APPENDIX B: SYLLABUS FOR CLASS ON
A Creative Guide to Exploring Your Life 183

REFERENCES 187

FURTHER READING 188

INDEX 189

Acknowledgements

We would like to thank Professor Alex Slocum for encouraging us to write this book. His unflagging support has been fundamental to the completion of the project. We also thank Andrew Hrycyna for his preliminary advice, which was so helpful in focusing our initial concept. We are especially grateful to Wade Roush for his generous contributions of time and expertise. His counsel was an enormous help in getting our manuscript ready for publication. We appreciate the support of our editor at Jessica Kingsley Publishers, Stephen Jones, and the encouraging words of Dr. Jane Richardson, who suggested that we contact Jessica Kingsley Publishers in the first place.

This book would not have been possible without the many people who contributed examples that illustrate the exercises in practice. Their work adds a richness and dimension to the book which would not have been possible to express in any other way. They include: Nia Beckley, Jacqueline Beer, Gabriel Blanton, Carolyn Bloom, Biyeun Buczyk, Harvey Burgett, Jacky Chang, Joy Dawson, Joy Ebertz, Omar Fernandez, Darlene Ferranti, Jacquelyn Gold, Flavia Goncalves, Javier Hernandez, Barry Herring, Pamela Herring, Courtney Drew Hilliard, Lloyd Sheldon Johnson, Phyo Kyaw, Sally Ling, Janice McCallum, Carmel Mercado, Terri Morse, Christopher Moses, Jeremy Orloff, Barbara Peng, Gregory Perkins, Lee Perlman, Stuart Pocock, Fredric Rabinowitz, Celia Ramsay, Lauren Ramsay, Valerie Ramsay, Wade Roush, Maitagorri Schade, Mirat Shah, Deborah Shomer, Alex Slocum, Walter Song, Christopher White, Karen Wilbur, Kiran Yemul, and Jessica Young.

Finally, we would like to thank all of the students who took part in our *Composing Your Life* classes. Their enthusiasm for the material and their commitment to this work has been an inspiration to us. In particular we would like to thank Jessica Young and Darlene Ferranti, two former students who have given us so much support and positive feedback throughout this project.

The Birth of this Book

We have designed this book to be a structured, guided tour of you—what you think and feel, where you come from, where you are now, and where you are going in the future. It is about self-exploration. It is about self-expression. It is about reflecting on the things you value and tapping into your own creativity.

Holly is a licensed psychologist and Graham is a professional photographer. We are two individuals with different backgrounds and expertise. We have come together to write this book to offer our perspectives in a collaborative way so that you, the reader, can benefit from a broad, multi-faceted approach to the process of self-discovery.

The key concepts and exercises in this book are drawn from a class on identity and self-expression (*Composing Your Life*) that we first taught together at the Massachusetts Institute of Technology in the spring of 2004. This class was offered under the auspices of the MIT Experimental Study Group, an alternative academic program for freshmen which specializes in interactive education. We knew that we wanted to devise a course that would guide students through a process of self-exploration and self-expression. Both of us had taught for many years in a variety of capacities, but had never collaborated to teach a single course from both psychological and visual perspectives. Our own interests in alternative education and in teaching collaboratively led us to outline a new class that combined several different disciplines (psychology, visual arts, and writing) in a creative and synthetic way.

Materials were developed for the class over the fall of 2003, drawing from our own professional and personal experiences and using a variety

of sources. These included texts on photography, portraiture, and fine art, and books on writing, memoir, self help, and psychology. We designed over 30 interactive exercises utilizing writing and visual arts to help students understand more about who they were and how to express this to others in a creative way. When we taught the subject, students engaged each other in classroom exercises which ranged from the playful to the profound. After each class, we went over weekly written comments from the students that gave us immediate feedback on what had happened in that class—what worked, what didn't, and why—and we modified the curriculum as needed. At the end of the term, we organized a two-week public exhibition of the students' final projects which culminated in a reception and oral presentation of each student's "portrayal of self."

The response to the class was remarkable: from the evaluations, we discovered that the class filled a void in the students' academic and personal lives, providing them with a creative exploration of who they were, had been, and were becoming. None of them had ever composed a mixed-media portrayal of self and few had taken the time (or been given permission) to really delve into who they were and what they valued or hoped to accomplish.

As we began to discuss the results of our teaching with peers outside of MIT, it became clear that the ideas explored in our class had implications for a broader audience beyond the academic community. Friends expressed an interest in the creative aspects of the exercises we devised; colleagues asked if they could use these exercises in their psychology workshops; professionals in the expressive arts therapy field wanted to incorporate our materials in their classes. Some of our former students reported back to us that they were drawing upon our exercises to continue their trajectory of self-exploration and self-expression on their own. Eventually, at the urging of our friends and colleagues, we set about writing a book that would take our academic seminar and turn it into something that individual readers could use as a tool for their own journeys of self-discovery.

Co-writing a book of this nature posed particular challenges. We spent a great deal of time discussing what voice to use, what audiences we are trying to reach, and how to best express our enthusiasm for the topic in a way that will be fun and engaging for our readers. We wanted

to integrate our voices and to synthesize our ideas so that we could present our work as a collaboration, which it truly is. We also wanted to include examples of how the exercises work in practice and to share with the readers the authentic personal experiences of others.

The result of our collaboration is a book that is unique in the way it approaches the idea of self-exploration. We hope that our passion for the subject will capture your imagination. It is our wish that this book will serve as a catalyst for your own creative impulses, and will encourage you to examine and express the ideas closest to your own heart.

How to Use this Book

A Creative Guide to Exploring Your Life is written with a primary focus on you, the individual reader. The book is divided into three parts: an overview of the ideas of self-exploration and self-expression (Chapters 1 and 2); a series of chapters which are largely exercise-based centering on particular aspects of self-exploration (Chapters 3 through 9); and two chapters that discuss how to incorporate the ideas into your life in an ongoing way (Chapters 10 and 11).

The exercises are designed to be enjoyable, creative, and thought-provoking. Most can be performed individually and at your own pace. Each exercise includes clear instructions that will guide you through the process. You are not required to be an artist for any of the exercises, nor do you need to think of yourself as an especially creative person. The exercises can be done in the order they are presented in the book, or you can choose to do the first ones that appeal to you. You can do them on a regular basis or as time permits. These exercises can be used not only for a single experience, but as tools that periodically can be reused and revisited. In this way you can establish a kind of yardstick, a means to measure your own progress and change. In whatever way you decide to use this book, it will provide a well-structured format in which you can take stock of your life.

We constructed *A Creative Guide to Exploring Your Life* to be useful to groups and facilitators as well as individual readers. Each exercise is designed with an initial set of instructions for the individual reader, followed by additional instructions for those who wish to do the exercises in a group setting. Group settings might include classes,

workshops, therapy groups, or even certain social gatherings—virtually any meeting where the goal is to use creative methods for self-exploration and self-expression. Doing this work in a group setting adds a new dimension by offering participants feedback from others. The insights gathered through these interactions can be a valuable part of the process of self-exploration. Feedback about our work helps us understand how well we are communicating our ideas and feelings. By seeing what other people have to say about their lives, we can learn about our commonalities and differences.

The majority of the book is devoted to the exercise-driven chapters. Each of these begins with a brief overview of the chapter's topic, followed by three or four exercises. Each exercise is broken down into step-by-step instructions including a list of materials needed. The exercises will take you anywhere from several minutes to a few hours, depending on the elements involved. The longer exercises can be done at your own pace and spread out over several days at your convenience.

In addition to the step-by-step instructions, each exercise is followed by examples which will help you understand how the exercise works in practice. The examples were contributed by men and women of diverse ages, ethnicities, and social experiences. These examples offer not only a model for doing the exercises yourself, but also a glimpse into the personal stories of others.

Each exercise includes a list of questions to consider. You may find that recording your responses to these questions helps you summarize what you have done. If you keep a record of your answers, you can refer back to them in the future to remember what you felt and to gauge how your viewpoints may have changed over time. For those who do the exercises in a group context, the questions can also serve as a starting point for discussion.

Chapter 10 will guide you through the process of putting together a "self portrayal," a personal mixed-media work that ties together all of the elements touched on in the exercises. Your self-portrayal is not restricted to the journal format. In fact, we encourage you to create something with dimension and texture. You can refer to it in later years as a personal document about your life, or even pass it along as a legacy to people who are important to you. You might consider displaying

your self-portrayal in your living space as a way to celebrate who you are and the work you have done.

Before you begin working through the exercises, you may want to assemble a small stash of the supplies most commonly used throughout the book. Most of the exercises involve some writing component. Many include creating something that involves drawing or collage. A list of useful supplies to have for the exercises might include the following:

- a writing pad, comfortable pens or pencils or computer
- a large spiral bound drawing pad or sketchbook—11 x 14 inches or larger
- scissors, glue stick, Scotch tape
- colored pencils, markers, and/or crayons
- a box of oil pastels or soft pastels
- a pack of construction paper with a variety of colors.

Since photography figures prominently throughout the book, it will also be important to have some way of making photographs yourself. An inexpensive digital camera is probably the simplest choice, along with a method for printing out your images. This can be done most easily with a simple home printer. As an alternative, images can be printed at most drugstores or other self-service printing centers at minimal cost. Having the ability to take self-timed photos is helpful too, although there are other ways to engineer self-portraits if need be (photographing into a mirror, for example). Exercises that involve photography will include suggestions on how to produce images pertinent to that exercise. You do not need to have extensive skill or background in photography in order to create useful and meaningful images.

Through its series of exercises and examples, this book will help guide you on your own journey of self-exploration. Whether used individually, in a group setting, or in a therapeutic environment, it provides the tools and structure for creative self-examination and self-expression in a dynamic and multi-faceted way. The ultimate goal of this book is to help you become more in touch with your identity based on a variety of influences such as family history and traditions, race,

ethnicity, and gender. By examining these influences, you can better understand how they have shaped your current sense of self. We believe that this self-knowledge is one of the best tools available to guide you on your path toward an emotionally healthy and purposeful existence.

1

The Journey of
Self-Discovery

Overview

The exploration of the self is our conscious attempt to understand more about who we are, why we do what we do, and how we want to behave and think in the future. This journey of self-discovery can be a dynamic exercise in which we not only study ourselves but also get feedback from others about how they view us. Understanding who we have been and what we are becoming can be exciting and rewarding, particularly when we use different tools such as art, photography, and writing to delve into ourselves in new ways.

In our present culture, we are not often encouraged to spend time thinking about who we are. We are told from an early age that what we do and how others perceive us are more important than who we are and how we feel about ourselves. Our educational systems devote a great deal of time to teaching us knowledge about academic disciplines, but little time to helping us know who we are. Most of us graduate from high school and college without ever having taken a good look at ourselves. As adults, we may spend time in therapy, participate in self-awareness workshops, use self help books, or write in a journal to explore ourselves, but many of us do not have the structured resources to take a journey into ourselves.

Exploring and understanding who we are is key to leading a successful and fulfilling life. It helps us to forge successful relationships and to excel in our professional endeavors. If we know who we are, we are

more likely to act in ways that are congruent with our true selves. If we spend time examining our cultural and personal backgrounds, we are more likely to act from rational thought rather than instinct, and more likely to question the prejudices and assumptions of our families and our cultures. [By looking at the effects of gender, ethnicity, and other factors on self-image and the values we hold, we are less likely to act from unexamined stereotypes.]

What is self-exploration?

Anytime we give ourselves space to look at who we are, we are involved in the process of self-exploration. This process can take many forms, including exploration with the help of others. One of the more common forms in Western culture is psychotherapy. Psychotherapists work with clients to help them find out who they really are and come to terms with those true selves. Another common way includes participating in self help workshops and classes. These settings focus on structured exercises and assignments that encourage us to examine ourselves within a group context. Retreats are a third way, where we move to a different physical environment apart from our daily lives so that we can focus on ourselves without the normal distractions. Retreats are often spiritually directed and can involve exploring ourselves within the context of a religious tradition. We can also explore ourselves through more solitary means such as meditation and journaling. Meditation involves quieting one's mind through various techniques in order to see who we are at our essence, letting go of previous beliefs and preconceptions. In journaling, we write about what we think and feel, often in an effort to make sense of ourselves and how we fit in with the world around us. Journals can focus on a variety of topics such as daily events, dreams, or moods.

As you work through the book, you may find that you are asking questions about your identity that you haven't asked before. This can be disconcerting at first. Sometimes we have taken something for granted about ourselves that is rooted in how we grew up rather than who we actually are now. We may see a side of ourselves we hadn't seen before, or we may evaluate our choices and views in a new light.

Why is self-exploration important?

Self-knowledge is at the core of an emotionally healthy person. Healthy people have taken the time to look inside themselves to see what is really there. They are better able to question traditional assumptions and take charge where needed. They are more likely to engage in positive relationships, both in the work place and in their personal lives. They are able to call upon a variety of coping mechanisms, not just the ones that have been instilled in them by others. An ability to observe our own actions, be active instead of passive, and be fully aware of the various pressures on us (such as family and cultural influences and gender role expectations) can give us greater self-esteem and help us handle difficult circumstances.

The ability to step outside of ourselves and observe who we are with objectivity is important for good mental health. In psychotherapy, this is called "the observing ego." Much of therapy is devoted to helping patients cultivate a greater ability to see who they are without being totally immersed in that self. The more we can sort out who we really are (our core personality and beliefs) from the person others expect or want us to be, the more authentic we will be in our lives, and the more joy and purposefulness we are likely to develop. As we examine ourselves, we may find that we are changing from what we used to be into something else. Sometimes in the midst of that change, we find ourselves confused about our identity. We grapple in different ways with the concept of the "self"—that part of us that is both permanent yet changeable We ask ourselves the question: If my identity is stable, then how does it change? If it is temporary, then who am I over time? How do I retain a coherent sense of self if I am changing? And, finally, do I really want to change?

There is an inherent tension between the consistency of the self and the fact that the self can change. Too much consistency produces a person who is not flexible and cannot learn from his or her environment. Too much fluctuation produces someone who does not have a solid sense of self, which can interfere with productive functioning. So many of us want to hold on to the self we know, and are afraid to explore it for fear it might change—yet change is exactly what we need. To rephrase an old saying, sometimes "it's the angel that you don't know

rather than the devil you know" that awaits you if you have the courage to risk some changes.

Understanding the roles we play is another important aspect of self-exploration. Some of these roles are driven by circumstances over which we generally have little or no control—our family background, the historical era in which we were raised, and our race, gender, and ethnicity. Other roles are of our own choosing, and offer us greater flexibility in how we interact with the world around us. In the following chapters, you will be given the opportunity to examine the roles you play in a variety of contexts, and reflect upon how these roles help to shape and define your identity as a whole.

The ability to know who we are and what we are about can guide us in a positive direction throughout all aspects of our lives—professionally, socially, and spiritually. Ultimately, self-exploration gives us the tools to take a more active role in creating who we are and will be. As we thoughtfully examine our past, we can better understand our present, and then make more informed decisions about our future.

A psychologist's perspective: Holly

In my work with clients, I find that many of them come to me with issues of depression or anxiety that stem primarily from a self that has been damaged by early childhood experiences. This self tells them that they have no power, can't change, and are doomed to repeat the same thing over and over again in their lives. One of the most important things I do is help them explore how that self arose and view possible alternatives. We discuss what it would be like to imagine that they don't have to continue to be that person who feels trapped and powerless. In my initial session with them, I always ask them the Miracle Question—"If you woke up tomorrow and you were the person you wanted to be, what would be different?" This gives us a framework of hope, of change, and of possibility. This change is not easy. We are often invested in remaining who we are despite the flaws in our existence. One of my clients, a man with a long history of depression, said to me once that "I prefer comfort over hope." He said that he was afraid that if he chose hope, life would become uncontrollable and he would lose any sense of stability that he had. His real progress in therapy began when

he was able to see that his comfort was, in fact, stifling him, and that his fears of the unknown were predicated on his family history of fear and not on any accurate assessment of his future.

Sharing the journey of self-exploration with another is an honored task. Sharing that with someone who is in pain is even more awe-inspiring. I have had clients begin their journey convinced that they cannot change, that life has shaped them in such skewed ways that they cannot get past their negative conditioning. One client told me when she entered therapy that she was certain she would always be a victim, that she was helpless in the face of an emotionally abusive mother (whom she inherited when she was born) and an emotionally abusive husband (whom she chose to marry). When she was able to see that she had choices as an adult that she did not have as a child, and that many of her actions as an adult came from feeling as if she were still a child, she was able to move forward with her life. She could then confront her husband in healthy ways, and view her mother as an unhappy woman rather than the truth-teller.

The process of reflecting on our lives can be exciting, stimulating, and rewarding. We can take this journey on our own, with a therapist, with loved ones, or in a group setting such as a class or group. This book gives you the chance to take that journey of exploration, which can help you grow and change as you need to.

A photographer's perspective: Graham

Photography plays a unique role as a tool for self-exploration and self-discovery. Since the advent of popular photography generations ago, people have had the power to capture images where, when, and how they like. This includes taking pictures of ourselves, our family, our community, and our environment. This power lies not only in the way the camera puts us in control of the images we record, but in the document our photography leaves behind. Once we have an image, we can refer back to it to reflect on a past event, or simply to jog our memories. We can use it as a tool to illustrate parts of our lives to others, as images have the power to communicate in a way the written word does not.

I have seen photography dramatically change the way people see themselves. I was once asked to photograph a man every several months over a two-year period. He had body-image issues, and was trying to document the transformation of his physique from (in his view) thin and underdeveloped to gym-buffed. In truth he was never unattractive or overly thin. The issue was in his own mind, fuelled by childhood family issues and fear of rejection. Over the two years, his body never changed perceptibly. What did change, however, was the way he perceived himself. He came to be more comfortable with his body and his body image. He learned to view himself differently over time by examining his images and seeing other people's reaction to them. He began to close the gap between his own self-perception and a more objective view of his physical presence. Moreover, he began to consider in a more serious way the difference between his physical appearance and what he felt was his true inner self.

But a photographic experiment need not take two years. Reviewing photographs we have of important people in our lives is an obvious way to start reflecting upon our world. We tend not to photograph people who have no connection to us. By simply taking stock of the photos you already have, you can create a framework for understanding in a visual, tangible way the people of influence in your life. As you look through such pictures, you may want to ask yourself questions like, "What was the occasion for taking this particular image? Are there elements of this photo that help me remember things I had forgotten? How do I feel when looking at this image?"

Throughout this book there are many examples of photos taken by others as tools used in the process of self-exploration. As you view these examples, consider ways in which you too might use photography as a medium to better understand who you are and what you value. This book offers ideas on how to look at yourself and your world through photography that you may never have considered.

Getting your feet wet

The following exercises provide you with an opportunity to make a quick "snapshot" of who you are right now. The exercises are brief and don't require any photographic equipment or art supplies. They are

designed to serve as simple starting points, to get you involved right away in the process of thinking about your identity. We encourage you to jump right in—you don't need to be overly analytical in this process. Two examples of each exercise are supplied to illustrate how the exercises work in practice.

Exercise 1: Who am I today?

Purpose: To help you understand your sense of identity as you are right now.

Materials needed: Pen and paper or computers.

Instructions:

1. Describe yourself in one paragraph. You may focus on anything you wish, including interests, personality traits, past history, future goals.

2. Now describe yourself in one sentence.

3. Finally, describe yourself in one word and draw a simple image that represents that word.

4. If possible, do this exercise with a friend and, at the end, include a one-sentence description of each other. Compare the differences in the descriptions.

Example 1: *A 58-year-old male*

Paragraph: I am a seeker of truth and connection. My mind and my heart are both very important to me, and it's difficult to find a way to be in both and have them work together. I'm a dad and husband. I'm a musician, a philosopher.

Sentence: A seeker of truth and connection.

Word: Seeker.

Figure 1.1: Sketch of the seeker.

> **Example 2: *18-year-old female***

Paragraph: I am funny, sometimes in a non-comical sense. I make myself laugh often and others less often. I like football, I hate shopping, I like people. My dream on-the-side job would be doing voices for cartoon characters, but I cannot do this on the spot. I like to sing, but I can't do it on the spot or alone. I'm rediscovering a childhood love for animals. I'm rediscovering who I was as a child. I'm rediscovering who I am.

Sentence: I'm expanding and shrinking at varying rates, making up who I am as I go along.

Word: Alive/lively.

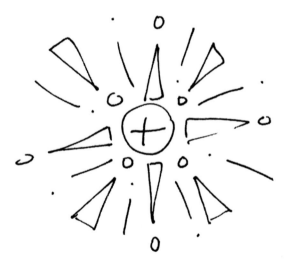

Figure 1.2: Sketch depicting liveliness.

Exercise 2: Roles I play

Purpose: To identify roles you play in your life.

Materials needed: Pen and paper or computer.

Instructions:

1. Write down as many roles as you can think of that you play.

2. Select two of your favorite roles and write a paragraph about why you enjoy each role.

▶ **Example 1: *19-year-old female***

Roles I play: Student, friend, girlfriend, aunt, sister, daughter, teacher's helper, tutor, partner, voice of reason, artist, water skier, devil's advocate, defender, writer.

Friend: My social nature and desire to help people—the latter probably stemming from my faith. Also, my parents always taught me to try new things/people and be kind and loyal.

Defender: Desire to be following the right path; also, a love of my friends and a desire to see them happy and treated fairly and supported. Harness a natural energy—I take action fiercely.

▶ **Example 2: *63-year-old male***

Roles I play: brother, friend, uncle, cousin, helper, performer, composer, collaborator, mentor, administrator.

Helper: In my personal life the role of helper brings me great satisfaction—when I am able to help another person reach a new level of knowledge, health, professional standing, or acceptance of different realities. I especially find joy in ministering to elderly people, on whom I seem to have a natural comforting influence.

Collaborator: In my professional life as a musician, the role of collaborator is very important and rewarding. My own best work seems to flow more naturally when working together with others toward a common goal, more than when I am pursuing a goal on my own.

Moving forward

Throughout the rest of the book, you will learn techniques for self-exploration with the goal of better understanding where you come from, how you think, and how you define your values and goals. You may find some of these exercises challenging. Questioning traditional beliefs about yourself, your culture, and your family can be uncomfortable at first, but the rewards can be tremendous. To follow a path that is strictly scripted by others keeps you from knowing your true self. Self-understanding can guide you in all aspects of your life, from deciding what kind of career you want to determining how you spend your free time. Taking a look at your core beliefs about yourself and the world around you, and reexamining these issues over time, helps you to shape a clearer and more conscious identity.

2

The Value of Self-Expression

Overview

Self-expression is a method by which we take what is inside us—a collection of thoughts and feelings—and turn it into something tangible so that it can be viewed by ourselves and others. At its most basic definition, self-expression is about someone presenting his or her own individual personality. The process of self-expression becomes an important means for self-discovery. Through this process we can learn about ourselves, how to present important parts of ourselves to others, and how to relate to others and to the larger world around us.

In this book we focus primarily on two ways in which we can express ourselves: writing (as exemplified by journals and blogs, letters, emails, essays, and poetry) and creating visual media (with an emphasis on photography, drawing, sketching, and collages of materials). Using any single medium can be helpful in expressing ourselves. Each medium has its own particular set of characteristics which makes it useful for presenting ideas in specific ways. When two or more modes for self-expression are brought together, however, there can be a synergy that brings even greater insight. A written description can offer up an image to our mind's eye; a photograph can transcend the barriers of written language. Bring these two elements together, and we can illuminate ideas in ways that neither medium alone can do.

Self-expression and self-exploration are interwoven concepts. As we understand more about ourselves, we are in a better position to

express who we are. And as we find different ways to express ourselves, we learn more about who this "self" really is. Sometimes our concept of self changes as we express it. Sometimes the expression changes as we shift in our sense of our self. Ultimately the two ideas are so interconnected that it doesn't make sense to discuss one without the other.

Discovering who we are through self-expression is an inherently creative process. As such, it is important not to judge our own realizations of self-expression against the work of others. Out of a desire to excel or to just appear competent, we can get caught up worrying about not being as good at "making art" as others. This can lead us to give up early in the process of creating something expressive and meaningful. The value that we gain from our work will be through what we learn about ourselves in this process, not by comparison with the work of others.

Visual means for self-expression

Visual art is defined as any art that you can see (excluding performance). As this definition implies, the pool of ideas relating to visual self-expression is vast. Graphic design, sculpture, print making, film, ceramics, doodling, sketching, drawing, painting, collage, and works with fabric, color, and texture are but some of the many genres of visual media available to us. Anything we can take in our hands and organize in our own personal fashion to create a visual statement becomes a mode for creative self-expression.

The power of visual images is undeniable. There is an immediacy of understanding that comes from seeing an image that is not always present in the written word. In writing we describe what we see, but seeing the actual image offers a presence of detail unattainable in written language. For this reason people are often drawn to images rather than writing. Images are universal. You do not need to speak a foreign language to have some understanding of a foreign image before you. In this way the visual image can offer a point of departure for deeper understanding.

This book uses photography as the main visual medium because it has unique characteristics that make it a particularly powerful tool for visual self-expression. Photography provides us with a method with

which we can easily create new images that reflect upon our world. When you are behind the camera, you have a special role in the making of your own history. When you take a photo, can you imagine how that image will be interpreted by other people in the future? How might you come to see the image differently as time passes? How can this process help you interpret images from your past, or from a time before your existence? The act of capturing a moment, and then keeping a record of it, can add a dynamic element to the process of self-exploration.

One aspect of photography that cannot be overlooked is point of view. It is important to understand how two separate people can view the same event and interpret it in entirely different ways. Point of view is flavored by many factors—some of which have nothing to do with the event itself, but have more to do with our own personal histories. Who we are and what we have seen and done before color how we interpret what we see now. When we take a photo, we are editorializing, telling a story from our own subjective standpoint. This editorial stance may not be conscious on our part. But how we approach a subject with a camera—our camera angle, whether we are close or far from our subject, the environment, the time of day we choose to make the image, the kind of light that is available, how we interact with what we are going to photograph—reflects on us and our unique point of view.

The act of taking photographs of ourselves is another way of understanding our own role in the world. Self-portraits allow us to be both subject and photographer. We can choose how we want to be represented, what we want to show, and when we want to show it. In this process there are multiple layers of self-discovery. The act of taking the photograph, of considering what we want to show of ourselves, is part of it. Pulling out the image later and examining it with the benefit of retrospection is another. Time plays a critical role in how we understand ourselves through our images.

Just as important as the new images you will create is the collection of existing images that relate to your life. Most of us have been photographed by others, most commonly by friends or family members who wish to commemorate some event, outing, or family function. And many of us have inherited family photos, images from before the birth of our parents and their friends and relatives. As the medium of photography is over 150 years old, it is possible for some people to have

images of their ancestors going back five or six generations. When looking at old photographs, it is important to learn how to read them for their meaning. Family photos carry a wealth of information about where we come from. How people dress for their time in history, their relationships with other people in the photographs, their body language, the environments in which they are depicted: all of this information is useful in understanding these people, and in turn understanding a part of ourselves.

Written means of self-expression

As powerful as images can be, there are some thoughts that can only be conveyed in the form of captured language—that is, writing. Writing is one of the most complex ways of interpreting our world. It takes on many forms, from the most mundane (grocery lists, phone memos, and reminders on post-it notes) to the lofty (novels, poetry, constitutions, and treaties). We keep diaries and journals, write poetry, maintain blogs, and write and receive letters and emails. Writing about our personal lives helps us understand who we are. It helps us to express a range of ideas and feelings. Writing can also offer us insight into a period of time in our lives. Reviewing our writing can help us remember what we were thinking, feeling, and doing at the time we wrote. In this way, a post-it note under the proper circumstances can have as much power as any other form of writing. The critical message is that our writing comes from us. It is one of the most common forms of self-documentation that we have and is therefore useful in helping to understand where we have been and what we have done.

James Pennebaker (1990), a leader in the study of the therapeutic power of writing, argues that writing regularly can improve one's mental health. Through his research, he has found that people who write regularly about their experiences and feelings are better able to gain perspective on who they are and handle their emotions more effectively. In this spirit, we encourage you to begin a journal, either handwritten in a notebook, or published online. You don't have to be a great writer to write and to gain benefit from writing. You just have to write in an authentic way about your own experience. You can write in your journal daily or weekly, or whenever the mood strikes you. You can

keep it for yourself or share it with others. We believe that if you take the time to begin writing on a regular basis, it will help you not only to express your emotions and thoughts but also to document your life, something you will find valuable later on.

Documentation

The methods of self-expression previously discussed can be grouped under the larger heading of documentation. Documentation is tangible evidence that something exists or has existed. When we think of documentation, we usually think of official papers, such as documents submitted as evidence for a legal proceeding, or papers that chronicle major events like birth, marriage, or financial transactions. But many other types of records can qualify as documents, from the written word and computerized data to audio-visual media (such as photographs, drawings, sketches, sound recordings, and video). Virtually anything that gives tangible and visible proof or testimony is a document.

Documents are crucial because they help jog our memories. They bring back specific information that we do not retain in our heads and provide us with a means by which we can revisit and reexamine our pasts. Without these records, we can lose valuable details that help us to better appreciate the subtle nuances of our lives. We can learn a great deal about ourselves by reviewing documents about our past with the benefit of hindsight.

Another important aspect of documentation is the ability it offers us to share information with others. Documents can be expressive tools that communicate, educate, and elucidate different aspects of ourselves, particularly when they are created with the intention of being viewed by others. They are tools of revelation and persuasion. They offer a means by which we can be seen and understood. They can supply others with a point of reference, a place to begin their understanding of us.

The concept of mindful documentation describes ways of consciously and intentionally thinking about where we are now and where we have been. Mindful documentation can be a way of commemorating the present with an awareness of the document's future implications. When making a document—whether taking a photo,

making a journal entry, or writing a letter—we should consider how well the document tells our story. Our memories are short and our lives are full. Having a thoughtful record to look back at in the future—whether it be a written document, a photograph, or a personal artifact—helps us mark our progress through time.

A psychologist's perspective: Holly

I was trained in a traditional way as a therapist, using the "talking cure" as the primary method in helping clients understand more about who they are and how to cope with their emotions and experiences. In my own life I knew the value of using different modes of self-expression. I wrote regularly in a journal, I used photography as a way of documenting my life and focusing on what I valued, and I composed poems when I was particularly upset which helped me give vent to what I was feeling inside. However, I didn't employ these methods with my clients until I started team-teaching a course on creative methods of self-exploration several years ago. Once I saw how eagerly our students responded to the material and reflected on how much I myself valued creative ways of expressing myself, I began to actively experiment with the use of visual media and writing with my clients.

I would ask new clients to bring in pictures of their families and loved ones and tell me about what they thought was going on in the pictures and how they felt when they viewed them. One client brought in several albums worth of pictures, another person brought in only pictures of herself and her friends, and a third client (a severely depressed man) brought in just one picture of his family and asked me to keep it. He said he felt safer knowing his family was in my care. In each case, I learned a great deal about my clients and also strengthened our therapeutic connection. In the case of another client who had trouble understanding how she really felt, I asked her to take some time each evening to write a few words about her feelings and then draw those emotions as best she could. She returned the next session with a book filled with vivid watercolors and said that this exercise not only was fun for her but also allowed her to understand her feelings from a different perspective.

With clients who said they needed time between sessions to process what they were going through, I asked them to try writing regularly in a journal. We discussed different ways of doing this, including writing to a specific person, to a higher power, or to themselves in the third person. One of the most effective modalities turned out to be writing journal entries with their non-dominant hand. One client said that struggling to write in this way and seeing how childlike her writing was enabled her to remember more about what it was like to be a child and brought up some unresolved childhood issues with which we could work.

In all of these cases, I have been moved by the power of the visual and the creative to assist clients in working through their emotions. Therapy at its essence is a journey of self-exploration in which the explorer is accompanied by a loving guide. That journey can be richer when the therapist supplies a variety of methods which help clients explore who they are and what they feel in creative and expressive ways.

A photographer's perspective: Graham

In my role as a photography instructor, I spend a lot of time discussing the intentions behind images. I ask my students to consider how their images will be viewed and by whom. At their core, images are a form of communication, and I want my students to be thoughtful about how their images will serve to communicate their ideas. Are their photographs intended to record events, people, or places? Is the photographer merely an observer, or does he or she play a greater role in the scenario being recorded? Did they take the photo with a particular agenda in mind, or was their photo-taking a passive act? If they did have an agenda, how well does the image they have created help to further that end?

One of the great pleasures I gain from teaching is in what I learn from and about my students. I find it extremely compelling to note the reactions from the students when others are looking at their images. Herein lies the test: will the person viewing the student's image understand what he or she had in mind? Does the image move the viewer? In what way? By taking the picture, each student is displaying their particular point of view. By presenting a particular image, they are making a

choice about which images they value over others. There are so many aspects of self-discovery inherent in this process. By examining their choices, perspectives, experiences, and feelings about their images and how they are viewed by others, the students learn about themselves.

Taking stock: A checklist

Before you begin the exercises in the following chapters, take a few minutes to consider the ways in which you currently express yourself and document your life. The tables below serve as starting points for this self-assessment.

Table 2.1: Forms of self-expression

Method	I do this now	I don't do this	I would like to do this
Blog	A	A	
Send emails	A		
Write in a journal	A	A	
Write letters	A		
Write memoirs		A	
Keep a calendar	A		
Write stories or plays		A	
Write poetry		A	
Take photographs	A		
Draw	A		
Paint		A	
Make ceramics	A		
Create with textiles		A	
Build things		A	A
Create video or film		A	
Make music			A
Act in theater		A	
Dance	A	A	
Other (specify)			

Table 2.2: Ways in which you document your life

Method	I do this now	I don't do this	I would like to do this
Collect or save old emails	✓		
Save letters sent to you	✓		
Keep old financial records		✓	
Collect photographs	✓	✓	
Save old date books	✓		
Keep travel souvenirs	✓		
Create home video		✓	
Keep old address books		✓	
Maintain a resume or biography	✓	✓	
Keep cards from gifts	✓		
Keep a journal	✓	✓	
Keep old class notebooks	✓		
Clip articles of value		✓	
Keep old picture IDs	✓		
Keep event programs	✓		
Keep a scrapbook			✓
Other (specify)			

Summary

It can be difficult to measure, contextualize, and understand the ideas and emotions stirring inside us, yet these feelings often represent the essence of who we are. Through the process of self-expression, we can organize thoughts and ideas that may have seemed chaotic, and give structure to that which was previously unstructured. Self-expression makes these things tangible so that we can better evaluate and understand them.

Self-expression also provides a bridge for others to understand more about us, what we feel, and what we think. In this sense, self-expression can be a teaching tool, a way of educating others about

our point of view. Being able to reveal ourselves and to have an authentic voice is crucial to a healthy life. Being seen for who we really are can be a profoundly positive experience, keeping us connected with those around us. We all delight in knowing that we have successfully put our ideas across to someone else. Likewise, we are disappointed when we have failed to make our point. The message that comes up time and again in self help books and in professional counseling is that good communication above all is the key to maintaining successful relationships, both personal and professional.

Beyond the quest for self-knowledge, self-expression provides us with a creative outlet. We can experience great pleasure and satisfaction in knowing that we have taken something from inside of ourselves (an idea, a feeling, a point of view) and found a concrete way to impress it on others. We take for granted that artists are compelled to create beautiful things, but this experience is no less powerful for the lay person. All of us can benefit from a chance to explore our creativity through different means. Although true artistic talent may not be teachable, creative methods and processes are. The secret is to be open to what we can learn through self-expression, and to be open to the pleasure of the experience. Expressing what we believe, feel, or see—making tangible that which was previously intangible—can lead to a deep feeling of fulfillment and propel us forward.

3

Turning Points and Key People

Overview

A turning point is a moment of change in our lives. Change can result in a different view on life in general, a revised sense of self, or a new course for our future. Some turning points are more important than others; it is not so much the events themselves as the way we interpret them that gives them significance. What kinds of turning points have changed the course of your life? Some can seem small at first (getting your first bicycle) but can have major consequences for you down the road (learning the value of independence). Others can seem major at first (not getting a job upon which you have your heart set) but end up being less important than you had thought (you end up having other job offers that are equally good). Sometimes they can seem totally negative (you develop a serious health problem) but end up having positive consequences (you become closer to your family and gain a fresh appreciation of things you had taken for granted).

When you think about your life right now, what stand out as some major turning points? Were they anticipated or sudden? Did they have to do with specific people, or with events around you? Do you view them as positive or negative? Regarded from one perspective, all events—whether perceived to be negative or positive—have the capacity to change us for the better if we can learn to understand them in a helpful way. Although some turning points can seem very dark with

no redeeming value, if we think about how to use them to further our emotional growth, they will have a purpose.

Our sense of self is influenced not only by turning points, but by important people in our lives. For most of us, our families deeply influence our sense of self. As young people, we tend to assume that the reality around us and the views of our family are "The Reality." As we grow older, we begin to see that our identity is very much connected to our families. Families, of course, are made up of individual members who may view us differently. Your father may see you in one way and your mother in another. The number of siblings you have and where you are in the birth order can have a significant impact on how you see yourself. Our family traditions (including cultural influences) are also basic determinants of who we turn out to be. Because we are born into these traditions, we may not understand how much they affect our sense of self until we are able to take a step back and assess them objectively.

People outside our families can also have an influence on our lives. These people may include friends, teachers, supervisors, mentors, adversaries, and political or religious figures. Their influence can be subtle or obvious, negative or positive, and sometimes both. We can be changed by things that they say or do to us. On a more subtle level, the way these people interact with the world in general can serve as a model for us. We observe what others do and incorporate that experience into our world view. Perhaps we don't like what we see—that too can be a powerful influence on how we view the world.

People in positions of authority can have greater influence on us than others since we expect to turn to them for help and guidance. We learn about our world in large part through the messages and examples passed on by authority figures, and we imbue them with special expectations. We look to people who are experts, those who have greater knowledge in a particular area than we do. Sometimes we learn from them in conscious ways, but often we are not fully aware how much an authority's influence affects us at the time. You may not know the impact others have had on you until much later, or until you explore the root causes of your beliefs.

Learning to objectively view the turning points and key people in our lives is, in large part, a matter of experience and critical

examination. We may have been involved with people or events that seemed relatively insignificant at the time, and only later come to understand their importance. Gaining this perspective can be an exciting part of the process of self-discovery. It gives us the chance to learn new things about ourselves, and to appreciate more fully the significant people and events that make up the fabric of our lives.

Exercise 1: Drawing my life

Purpose: To draw your autobiography through visual means, to get you thinking about where you come from and what is important to you.

Materials needed: Large sheet of paper or poster board, crayons, magic markers, paint, and other miscellaneous art supplies or objects at hand (feathers, felt, glue, etc.).

Instructions:

1. Using a large sheet of paper or poster board (at least 20 x 24 inches) and your choice of drawing media (such as crayons, magic markers, and paint), take 45 minutes to draw your autobiography in any way that you wish. The only restriction is that you are limited to the size of the paper. This exercise is about exploring your life through visual means, not about being an artist. Anything that you do is fine for this kind of exercise. Keeping this exercise to 45 minutes is important. It will force you to think quickly and to commit your first ideas to paper. Keep an eye on the clock, or set a timer if necessary.

2. Take a break for a few minutes, then come back and examine your visual autobiography. Now write a brief description of your visual autobiography as though you were explaining it to stranger. What things do you think are very clear? What aspects of your visual representation merit further explanation?

Additional instructions for groups:

Time frame: 90 minutes

1. Draw your visual autobiography. **(45 minutes)**

2. Take turns briefly explaining your visual autobiographies to each other. Ask each other any questions you may have about the drawing. **(30 minutes)**

3. At the end, discuss whether you see any major similarities or differences in the drawings and, if so, what this might indicate about people in the group. **(15 minutes)**

Questions to consider:

- Have there been any specific events in your life that have changed the way you view things? Did you view these events as negative or positive at the time they happened?

- What do you have as tangible proof of the major turning points and influences of your life? What kinds of images and writings do you possess that document these events?

- When you think about major influences in your life, you may think of personal items that act as triggers for your memory or are emblematic of the time, place, or people who have influenced you. Can you make a mental list of some of these things? Is there any commonality between these items? If you group these items together, what kind of a picture do they create about your life?

▶▶ **Example 1: My homes**

Figure 3.1: The image above illustrates all the homes where the "autobiographer" lived from the time he was born to now. What is most striking when you look at this image? Based on the information in the image, what do you think this person feels? Values? Is there anything that you would like to see depicted in order to better understand this story?

Example 2: 1985 to the present

Figure 3.2: The visual autobiography above takes a very different approach from the previous one. It is much more narrative in style, like a storyboard leading from one event to the next. What do you think this says about how this person thinks of his or her history? What do you think is of value to this person?

Exercise 2: Key people

Purpose: To help you think about the people who have had an important influence on you.

Materials needed: Paper, pen, or computer.

Instructions:

1. Write down the names of two or three people (not family members) who have had a major influence on you.

2. Answer the following questions about each person:

 ○ Under what circumstances did you get to know this person?

 ○ What did you learn from them?

 ○ How have you incorporated their influence into your life?

Additional instructions for groups:

Time frame: 30 minutes

1. Complete all the steps above, but choose only one person to write about. **(10 minutes)**

2. When everyone is done writing, pair up with someone you don't know very well and take turns sharing you answers. **(10 minutes)**

3. After sharing answers, reconvene in a large group. Comment on what you see as the biggest similarities and differences between your own answers and those of your partner. **(10 minutes)**

Questions to consider:

• How often do you think about the people of whom you wrote?

• How do you think these people would feel about what you have written?

• What would it be like to send each person what you've written about them?

▶ **Example 1: Carolyn's key people**
Maria Gonzalez
Ever since I was a very small child I loved anything to do with being creative in an inventive sense. We were very poor and lived on a

farm too far from any access to public art classes, so I taught myself from art instruction books and with art materials I received for Christmas. When I started 7th grade, I had my first real art instruction where Mrs. Gonzalez was the teacher.

I was in heaven. Mrs. Gonzalez encouraged my art and frequently praised my work as well as gave excellent instruction. Because of her recognition of my talent, I took my art-making seriously and was able to go on to receive a BFA from the University of Wisconsin School of Architecture and Design. So art class and art-making was one area in my life where I developed self-confidence and felt the happiest and most like myself.

In a nutshell, Mrs.Gonzalez was able to show me how to merge technique with my ability to see. To refine line, to understand perspective, color and theory, specific instruction on materials—the list is enormous. Most importantly she allowed and encouraged me to let my expression have free rein, no matter the medium. She was a truly gifted teacher. I was lucky to have her until I graduated from high school.

I set out to be an artist, but I have yet to make it really happen. Mostly this is because of circumstantial reasons, but I know one of these days I will come back to it. However, being a creative individual, I have continued to explore many means to express myself. I have studied dance, poetry, various styles of artistic expression such as calligraphy, Japanese brush painting, belly dance and the list goes on. Currently I have been learning graphic web design. I believe without Mrs. Gonzalez's early encouragement I would never have found myself in this way.

Jill Grange

In Jill Grange I met a true mentor. I was in my early 40s raising two sons, remarried, and looking to learn more about myself. Specifically I wanted to understand what the nature of feminine and masculine was. By this I do not mean sexual orientation. I was the third child in a family of ten. I had a sister five years younger and eight brothers. We all shared tasks. There was no strong delineation betweens boys' chores and girls' chores except physical strength. My father was the strong nurturer and my mother was not emotionally supportive but was a very strong person. She became a physician at the age of 48, and went on to become board

certified in emergency medicine. I had been a single mother of two sons without child support and had sole custody. That meant I also had to be both mother and father. So I didn't "get" female roles and male roles and was curious about feminism and the role women had played historically and culturally. I signed up for a class at the local junior college called *Women in Literature, Myth and History*, or something like this! Jill Grange was the teacher. Somehow it came out that she had been raised on a farm in the Midwest with six brothers. She was the first person I had ever met who had a similar background to my own. So I befriended her.

She introduced me to the rich, partially recorded history of women. I learned just what the feminist movement was about, why it had come about, and what it was trying to accomplish. I learned about women of myth, legend, and folklore—about the ancient goddess traditions and the beautiful rich art and culture that has been preserved from those times. I learned how to give voice to paintings with words in the form of poetry. I learned how to set my horizons bigger than I had ever dreamed possible, and, most importantly, about partnership and equality of gender and to expect and find that in relationship.

The things I learned which I have touched on in the paragraph above do and will continue to be of interest to me. There is no aspect of my life which was not altered by this knowledge. I was empowered and transformed to discover the rich cultural and artistic contributions of women for millennia. The first deity was *gaia* or earth mother: Jill Grange introduced me to all this.

The primary relationship of human to earth is now, more than at any other historical time, really important to get right because of environmental abuses, global warming, etc. By learning about the feminine, I learned to value the importance of a balanced relationship to our earth home. I believe the ancient earth-based traditions which recognize the importance of this balance between masculine and feminine aspects of self and society have much guidance to offer the human species as we find our way to harmony with each other and our Earth.

Example 2: Adam's key people
Robby

Robby was my high school physics teacher and I got to know her as a person when we started getting each other's jokes! I would use humor as a mask for my shyness, and she saw through this and played the game back. Most of the class had no clue what was really happening. We were trading physics puns several orders deep. This helped me to learn to not be shy, because life is too short to hide.

Under Robby's watchful eye, I learned from Robby the importance of always asking fundamental questions and persisting until I had answers. Perhaps the most important thing I learned from Robby was the importance of looking at a problem from different perspectives and using fundamental knowledge to analyze other problems. For example, she gave a daily weather report and described it in the context of the physics of what was happening.

Robby also had a colorful attitude with respect to the administration and its inconsistencies and the difficulties it often created for students and teachers. Robby was never afraid to challenge illogical time-wasting rules and this helped me to come out of my shell! To this day she is my role model for many aspects of life as I try to reduce time wastage because we all only have a limited amount of time here on earth.

I really respected Robby and loved her as a big sister, and I was thus happy on my own time to fix the broken stuff in her physics lab. One day when I was in BASIC programming class, I had a fight with the new teacher. I stormed out of class and went to Robby for advice (protection). The BASIC teacher showed up with the principal demanding I be disciplined. Robby stood up for me and told off the principal and the new teacher, and then told the principal that I was welcome to spend the time in her class as a teaching assistant instead of being bored in the BASIC class. I learned more physics, fixed more stuff, and also developed an appreciation for classical music. Because of Robby, I am no longer shy, I question everything, I live life to the fullest, and I never let anyone hold me back!

Donny

Donny was my first boss as a practicing engineer. A friend of the family worked at the company and told me they were looking for mechanical design engineer help. I had just graduated from MIT and was looking for a job in the Washington, DC area. I called for an interview and personnel sent me over to Donny. He was very intimidating with his deep serious voice. He kept asking me more and harder machine design questions and I kept having more and more fun thinking up solutions—always going back to the basic physics. He then took me to the lab and pulled out a robot gripper designed for a factory cell they were developing for the Navy, and he said "evaluate this for me." Based on what I learned from Robby, I said "I think it's way too big and complex for what you want to do." Donny said in a threatening tone, "This was designed by experienced professional engineers and you think they did it wrong?" I said, "Yes." He said, "So you think you can do better?" and I said, "I think I could." Donny smiled, because I think he liked my honesty or gumption and asked me how I might make it better so I thought and sketched what would turn out to be an award-winning patented double gripper.

From that moment on Donny and I became great friends and geek partners. He fed me challenging jobs and I provided nifty solutions. Donny always insisted I write up and publish my designs in conferences or journals, and to this day this has been a key component of my success. I am never shy about questioning designs, although I have learned to do it in a gentle manner so as to not put the designer on the defensive, and I interview people by asking them to solve problems.

Donny also had a zest for life and we shared many manly times cutting and splitting wood and making stuff. Donny was an expert skier and I am sad that we never got a chance to go skiing together. Donny was the dad I never had, and I was the son he never had. We were the best of friends and I will never forget him. When he died in an accident, it broke my heart.

Exercise 3: Turning points

Purpose: To think about significant turning points in your life that have had a lasting impact on you.

Materials needed: Pen and paper or computer.

Instructions:

1. Take a few minutes to think about a major turning point in your life.

2. Write about this event. What happened? How did this event impact you? In what way are you a different person because of what happened? What were the positive and negative aspects of this event? What is the most important thing you learned about yourself as a result of this event?

Additional instructions for groups:

Time frame: 45 minutes

1. Write about your turning points as in the instructions above. **(15 minutes)**

2. In pairs, share turning points and discuss similarities and differences. **(10 minutes)**

3. Reconvene in a large group. Discuss the common themes of your turning points and in what ways turning points have changed you. **(20 minutes)**

Questions to consider:

- What makes turning points so powerful?

- Have you experienced a change in the way you view certain turning points over time?

- Do you think there is such a thing as a turning point with no positive aspects?

▷ **Example 1: The MRI**

A few months ago, I had sudden partial hearing loss in one ear. Eventually my doctor arranged for an MRI scan just to rule out the

possibility of a rare benign tumor. I was left encased rigidly with nothing but my own thoughts for about 20 minutes. Doubtless the idea that just possibly I might have something seriously wrong meant that I inevitably reflected on where I was at in life and in particular what felt wrong and how would it be improved. My wife and I weren't getting on too well. We seemed wary of one another, prone to complain, and had an underlying sense of lack of communication and intimacy. So out popped this idea: just to break the pattern why don't I propose that we both be really, exceptionally nice to one another for a whole 24 hours. That evening, I put the idea to my wife, and she immediately agreed it was worth a try. We fleshed out a bit what "being nice" meant. We discussed mutual respect, kindness, listening to and having time for another, nurturing closeness, having fun and sharing laughter, etc.

The next 24 hours went like a dream, so next comes "How are we going to keep this up?" I suggested that we need to live "in the now" and avoid making comparisons with the past. We discussed the reality that inevitably we can't "keep it up" and one or other of us will "pierce the love balloon" sooner or later with some negative behavior and hurtful words. We agreed to not see that as the end of the world, and whoever is the emotionally stronger should pull us back together caringly, when need be.

Rather than just a one-day wonder, this event has unleashed a more positive feel over a longer period. We've had more laughter, tenderness, sex. I feel different in the sense that every day seems more fun, my underlying happiness gives me more time and energy to help others, I'm probably more fun to be with and am more productive at work. Even my golf might improve! I guess the most important thing I learned is that, even when things look bad, you can choose a course of action and way of thinking that can genuinely turn things around. Will it last? Time will tell, but I'm prepared to recall the MRI scan and what it stands for if things should look bad again in the future.

Example 2: Kenya, 1980

I taught school on an island off the coast of Kenya in 1980. I fell in love with one of the local boys, not romantic love, but more like

teacher/student love or parent/child love. This 18-year-old boy was smart, quick, easy to smile, and loved by his family but was poor. He lived in a house with a dirt floor with his mother, his aunt, and three cousins. He was out of school when I met him because he didn't have any money for tuition. I hired him to teach me Swahili and paid him 10 shillings ($0.75) a day. When I was ready to leave, he explained to me that he'd be unable to continue his education. I told him I'd sponsor him if he stood in the top 10 percent of his class and wrote me once a month. He did that for two years. I returned to Kenya in 1982, offered him the opportunity to come to the US to study and he accepted.

This was a huge turning point in my life. I felt more focused, I had a purpose, I was more stable and responsible and my life improved immeasurably. I had a family and all his Swahili friends in the US became my extended family. Those years were such fun. We practiced "verbs" at night: "take over, take in, take out, take down, etc." I wanted him to play soccer. He was so good. I watched him learn and thrive and become a productive adult. This experience made me feel needed, worthy, and helpful.

I realized after returning from Kenya that I was no longer interested in material things—a bigger fridge, a better car no longer interested me.

Exercise 4: Reflecting on family photos

Purpose: To use photographs as a tool to gain greater insight about your family.

Materials needed: Pen and paper or computer, photograph of your family of origin.

Instructions:

1. Go through photographs of your family of origin and pick one image which, as much as possible, includes all the members of your family.

2. Write a few paragraphs that address the following questions:

 o Why was this photograph taken?

- o Describe what you think each person is thinking and feeling in this photograph.

- o What do you feel now when you look at this photo?

- o Is there anything you see in the photo that surprises you?

- o If you gave this photo a caption, what would it be?

3. If you like, do this exercise with another family member represented in the photo. Have them write their responses to the questions above, and discuss your responses with each other.

Additional instructions for groups:

Time frame: 60 minutes

1. Bring the photo and your writing to the group.

2. Taking turns, each person puts his or her photograph in a central place. Others in the group gather around and guess aloud about the following: What do you think is going on in this photo? What do you think the people are thinking and feeling? If you had to write a caption for this photo, what would it say? Once participants have guessed at what is happening in the photograph, the owner then reads his/her comments. **(50 minutes)**

3. Discuss differences between how we see our own families and how others see them. **(10 minutes)**

Questions to consider:

- Using visual cues from the photograph of your family (people's body language, the physical arrangement of people within the frame, facial expressions), what can you glean about the feelings of those photographed? What does the photo tell you about the relationships between the people in it?

- Do you feel that your role within your family is expressed somehow in the photograph? If so, what are the visual cues that indicate your role?

- What did you learn from other people's observations of your photograph?

Figure 3.3: This family photo is from the 1960s. For this example, the two daughters both responded separately to the questions below. Pictured from left to right: Denise, Mom, Dad, Helena.

- Did the group feedback on your image relate accurately to what was actually going on? If not, why do you think there were differences?

Example 1: A rare moment in the Smith family
Part I: Denise's impressions/memories of the photo
Write briefly about the occasion when the photograph was taken.
I think there was some event that we were getting ready to go to. I'm kind of dressed up so I think there was something at the high school, maybe my graduation. The photo was taken to commemorate the occasion.

Describe what you think each person is thinking and feeling in this photograph.
Mom is tickled by something saucy that Helena has just said; Dad is momentarily perplexed, just trying to think of a good come-back to Helena's comment; Helena is in an adolescent

rebellion wondering why she has to participate in such ridiculous maneuvers; and I am amused and delighted with my silly family.

What do you feel now when you look at this photo?
Wow! My sister and I are two hot cookies. Helena is sort of sultry and I am sort of radiant.

Is there anything you see in the photo that surprises you?
The first thing is the look on Dad's face, but I think I came up with the right explanation for that, so then it is no longer surprising. The way my hair is draped across my face is sort of surprising... What was I thinking? I thought I went in for more of the classic look than that. Helena looks stunning and beautiful, and that is sort of surprising given all the angst of those years. I must say I'm kind of surprised by the look on my face, too—there is more light there than I remembered having!

If you gave this photo a caption, what would it be?
A rare moment in the Smith family.

Part II: Helena's impressions/memories of the photo
What was the occasion of this photo? Why was this picture taken?
This was taken by someone (who?) somewhere (where?) probably around 1965 or 1966. I don't remember what the occasion was, but it looks like we are dressed up for some get together—it seems pretty posed to me.

What do you think each person is thinking and feeling in the photo?
Denise—life is good, I like my family and feel warmly towards them. Mom: I am happy to be a faculty wife with a wonderful family; Dad: I hate having photos taken of me—I feel squashed between all these women, why aren't there more men around? Helena: basically I really don't feel part of this family much at all. I am more interested in the person who is taking the picture, I am also aware that I am experimenting with lots of makeup and feeling feminine and attractive which is a new thing for me.

What do you feel now when you look at this photo?
I like the fact I look so glamorous, but I seem somewhat detached. As I look at my Mom, I feel nostalgic—I never really got to know

her until my Dad died and then we spent a lot of time together—I miss her a lot still even though she died five years ago. My sister's warmth and vitality shine through in this picture, but she's had a lot of hard times since then. She still has that warmth though. My Dad's anxious stiff side certainly came out in this photo—it's not a part of him I particularly liked. I also think this photo represents his discomfort being hemmed in by women in any way, shape or form. I'm not sure he really liked or respected women all that much.

Is there anything you see in the photo that surprises you? If so, what is it and why is it surprising to you?
For starters, I don't remember feeling at all attractive when I was that age but I guess I was. I don't know why I had such a low opinion of my looks—it was a real struggle for me to ever feel attractive. My father looks so uncomfortable and out of place—he usually was the center of attention but he doesn't look that way here. The Mom I remember from this picture is very different from the Mom I got to know later—she seems very formal and almost artificial in the picture (Betty Crocker after a drink said one friend who saw the photo) and that's not who she was at all later on. My Dad is fun-loving and outdoorsy so this picture seems totally strange except that he didn't like to have his picture taken. The photo doesn't represent what I think my family was all about: informal, high spirits, outdoorsy, casual, intellectual.

If you gave this photo a caption, what would it be?
One uncomfortable man surrounded by three pretty women.

▷ Example 2: Horsey ride

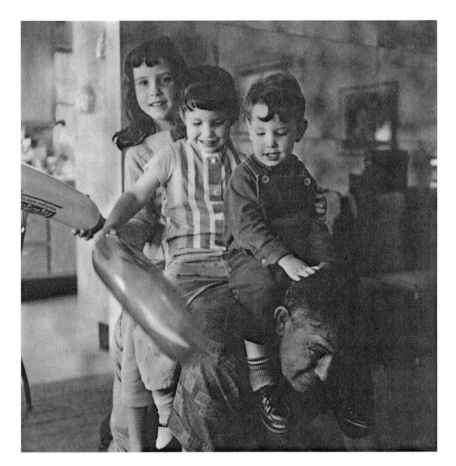

Figure 3.4: The writer of this exercise is pictured on the far left. The photograph was taken some 42 years prior to the writing that follows.

Write briefly about the occasion when the photograph was taken.

Judging from the background, this was our house on Monte Vista Drive. I was probably eight, my sister five and my brother three years of age. We're riding on Dad's back with logo-printed balloons (freebies from some promotion at a local business), the photo taken by my mother. I'm guessing that the photo was somewhat posed, springing from an impromptu moment when

one child was getting a "horsey ride," another climbed on to join the fun, and then we were all encouraged to pose for a photo.

Describe what you think each person is thinking and feeling in this photograph.
I'm guessing that the younger kids were part of the original play, and were enjoying the game—we all loved this kind of attention from my Dad, who was pretty generous with using his body as a playground for his kids when we were young. I'm sure bonking him with the balloons was part of the game. I think at the time, everyone was having a good time just messing around, and my mother wanted to capture this on film. The fact that we are stacked on in birth/size order says that Mom posed us to some degree. I'm guessing from my face and posture, that I'm being somewhat careful about my Dad's back—my feet are on the floor—and I'm looking at the camera/photographer, so I think I was paying attention to instructions. Dad looks like he's having fun, and is patient and smiling. My brother looks a bit tentative, careful, maybe for fear of getting bucked off? He's watching for clues about what will happen next. My sister is bonking the balloon, and looks like she's having fun being a bit wicked.

What do you feel now when you look at this photo?
This was the first place we lived where I became conscious that we were not completely financially secure; I remember we availed ourselves of free stuff as often as it was presented—not that we'd ever miss the offer of a free balloon—what self-respecting kid would? And I remember some of our neighbors weren't the most wholesome types, and that this was a pretty working class neighborhood.

I'm amused by the birth sequence order—I've often felt that too much responsibility was placed on me to look after the younger ones, and that we were always treated with our birth order as a pretty important kind of caste system.

While I very much enjoy looking at many of these photos from our past, we were so steeped in past events that the past became a major focus for all of us. We rehashed this stuff over and over. The problem with this became evident to me as I moved through adolescence and on, when my habit of talking about my past irritated my friends and lovers hugely. I have made considerable effort to turn my back on some of my past, because it was the place that was

secure, but it prevented me from embracing change easily and I have always had difficulty looking to and planning for the future.

Is there anything you see in the photo that surprises you?
No, not really. As I said, the past was always pretty clearly etched in my brain—it all fits.

If you gave this photo a caption, what would it be?
Horsey ride.

Bringing it all together

Studying the pivotal points in our histories and how we responded can help us understand the major contours of our lives as well as our detailed behavior patterns. How conscious are we of these past influences? When we make major decisions today, are we able to connect these decisions to past experiences? How can we take the ideas that were explored in each exercise and use them in our lives to reshape our decision-making and to encourage positive change?

The way you think about turning points and major influences may change over time. It may be helpful to redo the exercises here periodically, say once every couple of years, to see how the influences you consider to be the most critical now may shift. It can also be interesting to note whether you've changed the way you depict important moments in your life. For instance, do you draw with different media? In a different style? Do you go for the chronological approach, or is there a different structure to your drawing that favors thematic connections? The way in which we choose to draw our lives says a great deal about how we interpret our world.

The idea of interpreting key events is to understand not only their consequences, but how we handled them. Sometimes events that seem devastating at the time can actually turn out to have positive consequences for us in the long run. But without conscious awareness of these life-changing events, we are less likely to feel in control of our lives or really know who we are. It is important, therefore, to regularly reassess where we are now, and to review past events with an updated perspective. Keeping a journal is one way of doing this, whether it's an online blog or a book you write in. Talking with others (friends, coun-

selors, advisors, relatives, etc.) about important events in your life is another way you can take stock of how you have changed and why.

While critically examining key people in our lives, we may find that they have had an influence on our feelings about ourselves and the world around us that wasn't obvious before. Openly examining family members, mentors, friends, and other important people who have shaped our lives helps us remember who we are and how we have gotten here. All of us are influenced by others from the time we are born. The question is how we are influenced, and whether or not we want this influence to continue to define us. For those who have had a positive influence on us, we might consider sending them a letter of appreciation.

Few of us set aside time to assess how family interactions influenced the way we and other family members turned out. Selecting a family photograph and putting oneself in the place of each person in the picture can help us to understand our parents or our siblings a little better. Captioning the photograph helps delineate the family style: Was your family open or more closed, informal or more formal, intimate with each other or more distant? If you have the time and interest, try this exercise with a family member and see how your views differ from theirs.

In the coming chapters, we will revisit the core concepts of influence and change in a variety of ways. What influences us in the first place? How visible is this influence? How does it help to create change in us? Are we in charge of that change? Are we even aware of it? Issues addressed later in the book—concepts of gender, race, ethnicity, and roles—all affect the way we understand the key points in our lives. The exercises in each chapter are designed to help you investigate those questions through the cyclical and interwoven process of self-exploration and self-expression.

4

Gender and Self

Overview

gender is learned

In general, we are born into male or female bodies distinguished by their reproductive organs. We typically know at birth (and even during pregnancy) who is male and who is female. From the moment we are born, we are categorized as male or female and known that way by everyone around us. Sex is the term that generally refers to the physiology of our maleness or femaleness. Gender, on the other hand, is the expectation of the roles that are associated with those physiological traits. These roles are learned early on and are taught to us in a myriad of ways. Parents, teachers, peers, childcare workers, and the media all teach us that boys act in certain ways and girls in others.

In his best-selling book *Real Boys* (2006), psychologist William Pollack talks about the "boy code" which boys learn almost from birth. The code consists of being tough physically, not relying on others for help, and not showing feelings of vulnerability, hurt, or need. As boys grow up to be young men, the code for males includes being successful, being right in all situations, being sexual and aggressive, providing for others, and, above all, avoiding traits considered feminine. One of the most humiliating things you can say to a boy is "you're acting like a girl." A man who shows his feminine side is often branded as wimpy or perhaps even homosexual. These restrictive roles put men in what Pollack calls a gender straitjacket.

Young girls are also expected to follow a set of norms. These include being polite, neat, and well behaved. Girls who are physically active are called tomboys—a term that is not as pejorative as "wimpy"

for boys but is still confining. As girls grow up to be adolescents and young adults, they are given an additional set of rules, including taking care of others (even at their own expense), being pretty and sexy (but not too sexy, lest they be seen as sluts), being generally passive, and worrying about what others (especially boys) think of them. Psychologists Lyn Brown and Carol Gilligan discuss a decline in self-confidence and self-esteem among adolescent girls in their book *Meeting at the Crossroads* (1992). Brown and Gilligan find that girls in their early teens often become unhappy with their bodies, putting them at risk for bulimia and anorexia, and that they focus their attention on pleasing others (often the boys who surround them) rather than on bolstering their own self image.

The norms associated with being male or female are often not well understood, especially by adolescents who are preoccupied with trying to establish their own identities. If you are surrounded by something your whole life, it is hard to imagine what life would be like without it. Since most of us are born into unambiguously male or female bodies and live in cultures that make clear distinctions about appropriate behavior for each sex, we often have a hard time seeing how much of our identities is really us, and how much is based on the gender roles we've been trained to accept.

The gender norms mentioned previously are prevalent in mainstream American culture. Brown, Gilligan, and Pollack have done their research primarily on white, middle-class boys and girls in the United States. Depending on our culture, we may grow up with very different ideas about how men and women should think and act. Not all cultures have the same expectations about what men and women should do. Even within one culture there are many subcultures. It is therefore important to make note of the messages your culture sends you through popular media such as advertising, parental expectations, academic environments, and other sources of socialization.

The exercises in this chapter give you the opportunity to explore the impact your gender has had on the way you think, act, and feel, and perhaps to imagine what life might have been like if you had been born into the body of the other sex. Once you are more aware of these issues, you are in a better position to make conscious choices about whether you want to continue in the paths that were laid out for you,

or try something different. It would be useful for you to consider doing some or all of these exercises with a friend of the other sex. Besides being interesting and fun, the contrast between you and your friend could serve to further illuminate some of the ways in which you have learned to act as a man or a woman.

Exercise 1: Gendered photos

Purpose: To reflect on your gender and its implications through photography; to critically assess what it means to be masculine or feminine and to reflect this assessment in a self-portrait.

Materials needed: Camera, paper and pen or computer.

Instructions:

1. Consider the events that have taken place this week when you were most aware of your gender. Think back on your interactions with the people you have met throughout the week, the ways in which you responded to them, and—most importantly for this exercise—the ways in which they responded to you. Based on your reflections, take a self-portrait that strongly expresses your masculine or feminine identity. Think of a particular experience where you were keenly aware of your gender, and make your self-portrait with this experience in mind. You may not be able to literally recreate the event for the photo, but think about ways you can represent the essence of what made you feel most masculine or feminine during that event. You may want to take a short series of photos to illustrate your idea.

2. Once you have taken the photo, write a few paragraphs about the experience that prompted the photo. Reflect on how it made you feel.

Additional instructions for groups:

Time frame: 60 minutes

1. Bring your photos to the group. Present your images for others to see and share why you chose to depict that event. Comment on how it feels to be depicted in this particular scenario. **(30 minutes)**

2. Discuss what you believe to be some of the main advantages or disadvantages of the people portrayed in the photographs. **(30 minutes)**

Questions to consider:

- How do you think others view you when you play the role in your photograph?

- What advantages or disadvantages have you experienced being male or female?

▶ **Example 1: The first date**

Those few minutes of anticipation before meeting someone for a first date have been some of the most agonizing times of my short-lived life. I say "short-lived" because I'm only 21 and perhaps when I look back to this exercise in the future, a first date will seem so trivial in comparison to other challenges I will experience. It's in those few minutes of waiting that my stream of consciousness is in full throttle. I become extremely aware of my appearance, rechecking my little pocket mirror every few seconds, wondering to myself how I should act, what I should say. Different scenarios play out in my head one after the other, as I try to figure out what the evening might bring. Thinking back on my numerous first dates, the idea of making a good first impression was the main factor that influenced how I felt about myself and my decisions on how to act. I was never sure how the guy I was meeting for the first time felt about me. I did not know what his perception of the world was, what his beliefs and views were, so for me, the safe way to go was always the orthodox path: act feminine enough or act in line with what he would expect so that he wouldn't think me strange. I would act more feminine than I usually see myself as to get approval. I used my femininity as a cover as I determined whether this person would be someone I could get along with. It was a means for me to mask myself, I felt, for his comfort zone, testing his boundaries, seeing whether disclosing other aspects of my life would not be a turnoff. When meeting new people, generally first impressions are not such a big deal, but since it's one on one, I was more sensitive about making a lasting impression.

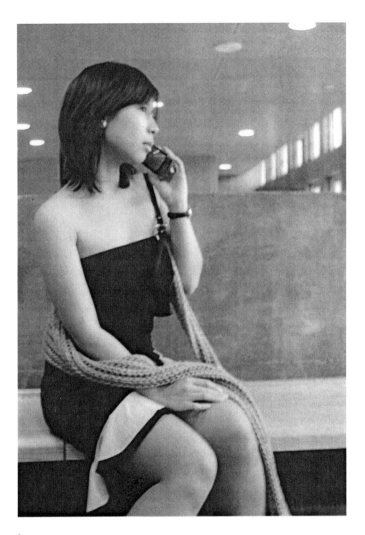

Figure 4.1

For most of my life, I have seen myself as a tomboy. If asked to
choose between comfort and fashion, I would choose comfort.
Blood, guts, mud, paint—I don't get squeamish if it is me making
the mess. It has only been recently, with the prospect of job inter-
views, that I've become more aware of dressing better. Otherwise,
my daily outfit as far back as I can remember has been composed
of jeans, sneakers, and a T-shirt. When I first started dating, to play
this role of a "female" in a first date was a monumental task. I felt

so out of character and so self-conscious that it took away from me being able to truly enjoy the date. I was so conscious about maintaining my appearance, acting appropriately, and looking for the right cues, that I don't quite remember all the details of what actually took place during the evening. I can't even say with certainty whether the other person enjoyed the date. Good thing these first experiences occurred during the beginning of high school, when "awkward" was acceptable. With more experience, it became easier to play the part. Just like changing clothes, playing this more feminine role involved me adding a layer of "personality" to who I generally was as a person. And just as quickly as I had put it on, after the date, I could take it off again.

The primary advantage to playing the feminine role during a first date is that as you are meeting someone new, you can determine whether you get along with the other person without risking being "scrutinized." There are also monetary advantages to being female. I found that if I acted more feminine, the guy was more likely to play his stereotypical part and pay for dinner, the movie, or whatever. This was nice from time to time, but unnecessary. Now I would rather not play around with this unspoken power, this feminine mystique. A little attention here and there was also an uplifting experience.

In a way, since I was acting a little differently from who I generally was, I was not completely truthful during these first dates. This was something that I couldn't help, especially if I wanted that first date to work out. At first, playing the role forced me out of my comfort zone; it made me feel awkward and unconfident at times. To top the list, the worst disadvantage was that sometimes, I would receive too much attention—from the person I was with and passers-by—because I was dressed up more than usual. For me, this attention was often more than I was comfortable with.

How did others view me in this particular situation? I can only imagine. To both young and old, I was probably a manifestation of the stereotypical "love-sick" teenager, giddy and antsy, as I waited for my evening date to arrive.

▶ Example 2: The men's retreat

Figure 4.2

I was at Esalen, enjoying the men's retreat there. Down at the baths there are several hot tubs and a co-ed changing room. Men and women are naked in the hot tubs. The picture is of me in the shower room looking out at the ocean. It represents not only my ideal shower room, but the freedom I feel in this place. Naked men and women share the space in a sensual, not sexual way. It feels like our uptightness about our bodies really creates more issues than there are when everyone is ok with their natural body state.

The group talked about the idea of men being scary to women. One of the guys brought up the analogy of men as being like bees. The penis is like the stinger. We can be dangerous, but most of the time we are not. We can be nurturing, loving, and fun. Bees only attack when threatened. Women and other men often just see the "stinger" when they see a man, not his full self. In the photo I feel

free but I do not show my stinger still. It is implied in my naked-ness.

I feel free and alive and a part of the human connection to others. The nakedness is literal and a metaphor for how I'd like to be as a man. The disadvantage is that I know that someone will misinterpret me and make me into something I am not and then create a threat, creating a reality that doesn't really fit.

I feel like those who know me and are intimate with who I am will say, "That is Joe." Those that don't know me will say, "That guy is an exhibitionist who is intimidating." That is the dilemma for me and other men. We are men but we are not in attack or defense mode all of the time. In fact, that is very little of what defines us. Yet, in everyday life, those who don't know me assume the worst, creating cold, sterile and fearful interactions no matter how open I am with them.

Exercise 2: Reverse gender autobiography

Purpose: To help you understand better how being born male or female has molded the way you think, act, and feel. Contrast often brings out the hidden themes that we take for granted.

Materials needed: Computer with a word processing program.

Instructions:

1. Write a short autobiography (two to four pages), focusing on key events in your life which you think have shaped your character today.

2. Once you have written your autobiography, you should title it "Gender Autobiography" and save it. Then go through and change all the genders in your essay. For example, "he" becomes "she," "aunt" becomes "uncle," "Carl" becomes "Carla," and so on. The second piece should be saved with the title "Reverse Gender Autobiography."

3. Take some time to write about what you notice when the genders are reversed. What do your autobiographies say about the possible impact of gender on how you see yourself and others? How others see you? Expectations for the behavior of each gender?

4. If you want, find a friend of the other sex to do the exercise with you and compare what you've written.

Additional instructions for groups:

Time frame: 45 minutes

1. Bring your reverse gender autobiography to the group and hand it to one designated person.

2. That person will start reading from each of the autobiographies, with the instructions that as soon as something sounds a little strange to people they should raise their hands. After three people have raised their hands, the person reading the autobiography stops. People who raised their hands say why it sounds strange. The reader then starts reading from the next autobiography and repeats the instructions above until all autobiographies are read or 25 minutes have elapsed. **(25 minutes)**

3. Make a list of what people found strange and discuss what this list says about the evidence of gender roles and stereotypes in our culture. **(20 minutes)**

Questions to consider:

- Based on your gender autobiography, what advantages and disadvantages did you experience growing up?

- Based on your reverse gender autobiography, how different do you imagine your experience might have been growing up if you had been the other sex?

- Do you see yourself differently as a result of doing this exercise? If so, in what ways?

▶ **Example 1: Reverse gender autobiography (male reversing to female)**

… I remember being in this class the other day and introducing myself to this boy. He seemed so fascinated by me and while the assignment was to learn about each other, he kept defaulting to letting me speak about myself and my experiences and opinions etc…for God's sake why couldn't this guy have a little more self respect…here I was dominating this conversation and trying not

to and he just let me walk all over him… My oldest sister was chilling out with her friends in the basement watching Die Hard or some mega-violent flick like that. My other sister had a go-cart and her friend had a dirt bike and they liked to race them through these woods by our house…

Advantages

I supposed I got all the advantages associated with being a boy. I was destined to be good at math, etc.

Disadvantages

I was expected to be able to control my emotions which is unreasonable to expect of me and perhaps led to issues in my life.

What would have been different growing up the other gender?

My relationship with my brothers would have been completely different, no trying to impress them with machismo, I'd probably have steered clear of them completely.

What did I learn by doing this exercise?

The accusation that many women see me as a "sack of testosterone" is perhaps true. I grew up in an extremely classical "masculine" situation and am very stereotypical in many ways for better or worse (perhaps worse).

Example 2: Reverse gender autobiography (female reversing to male)

I grew up in South Florida with my parents, younger sister, and older brother. When the three of us were born, my dad stopped working in the jewelry business. Since then, he has stayed home and done the majority of the housework. My mom is a urologist…

… When I was six years old, I "got married" to my first real girlfriend Molly. I wore my ballet costume, Molly wore a baseball cap, and my brother played "Here Comes the Bride" on the piano…

…like most boys, I downplayed my math and science interests in middle school and early high school…

…at the age of 14, I had a concrete idea of what I thought made "the perfect girlfriend" (probably mostly formed from what I had seen girlfriends to be in movies and magazines)…

…when I broke up with my first girlfriend, I was very angry with myself for messing up the relationship… I quickly started losing large amounts of weight…

Advantages
I had very supportive parents who encouraged me to pursue any and all fields of study.

Disadvantages
I grew up in a city in South Florida known for male plastic surgeons and their "trophy wives." Many of my female peers aspired to marry someone rich.

What would have been different growing up the other gender?
I don't think my experience would have been very different at home. However, I do think my relationships would have been quite different.

What did I learn by doing this exercise?
I don't see myself very differently since doing this activity since in other gender studies classes I have taken, I have been asked to think about how I have been influenced by my gender.

Exercise 3: Gender stereotypes

Purpose: To identify cultural stereotypes about gender; to examine how these stereotypes either support or get in the way of being who you really want to be.

Materials needed: Large sheet of paper or poster board, a writing implement, two or more magazines (preferably ones that have a strong gender bias, such as male or female fashion magazines or health and fitness magazines), scissors, glue.

Instructions:

1. Look through the magazines and identify images or headline text that portray stereotypes about your own gender. Cut out 10 to 15 images and paste them on a large sheet of paper.

2. Examine the pictures you have cut out and write down your feelings and thoughts about what you see. What do you like and dislike about these stereotypes? Which stereotypes fit best with

who you are or would like to be and why? Which ones get in your way of being the person you want to be?

Additional instructions for groups:

Time frame: 90 minutes

1. Create collage as in instructions above for individuals. **(45 minutes)**

2. Pair off with someone of the other sex and exchange your gender collages. Take five minutes to write down your feelings about the images they have chosen. Focus on what you think would be difficult about being the other sex and living up to (or confronting) these stereotypes. **(5 minutes)**

3. Share your comments with your partner. What similarities and differences do you see between the two portrayals? **(10 minutes)**

4. Reconvene in a large group. Discuss how stereotypes may be helpful or harmful to each gender. **(15 minutes)**

5. Finish the discussion by asking yourself, "what is one thing I could do differently to tackle negative stereotypes about men and women?" Share the answers in round robin fashion. **(15 minutes)**

Questions to consider:

- Do you think that the images you chose depicted fair expectations about what it means to be male or female?

- In the periodicals that you saw, did you wish for any depictions that you were unable to find? If so, how would you like to see your gender portrayed?

- What are some of the expectations placed on males to act in certain ways? What happens if they act differently from the norms?

- What are some expectations placed on females to act in certain ways? What happens if they act differently from the norms?

Note: The examples that follow are taken from the exercise when done in a group setting, with commentary from both genders on each collage.

Example 1: Female stereotypes

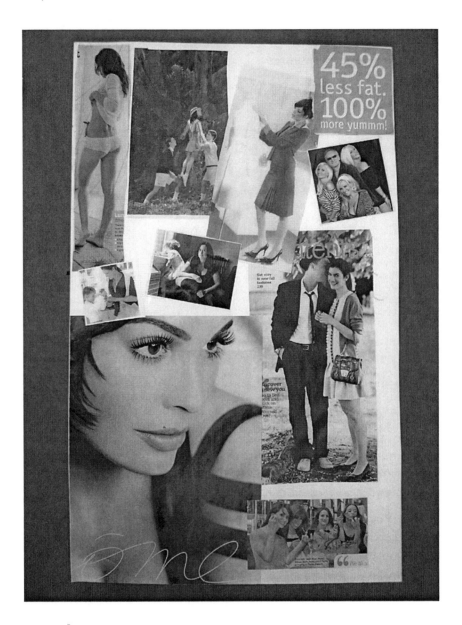

Figure 4.3

Female commentary: These pictures are a compilation of stereotypes I see in everyday media. Concepts of beauty, how I should act in relation to men, ideas of health and "dressing for success" are pervasive throughout these images. "What is the ideal body? How should I dress to command respect? How should I take care of myself?" These are all questions that come to mind.

What I like: I like images which represent or show a sort of delicateness and attention to detail. So images where the woman posing in somewhat exaggerated form, the clothes they wear, appeal to me. The intensity of colors, contrasts of shades in makeup, skin tone, and clothes—I am all aware of. Sometimes I can't help but compare myself to these images.

What I don't like: Feeling pressure to change what I wear. Feeling pressure to exercise to have this "healthy appearance." I don't like the fact that "appearance is everything," but in this world, it plays a big part in your success. I feel like I use these images as standards and I use them to make sure I'm still on "key."

Male commentary: The girly girl, sexy, skinny, perfect housewife. Women have to care and frankly if I was one, I wouldn't. I mean, yeah, I'd try a little, but not to the extreme that our society tries to make women go to.

Example 2: Male stereotypes

Male commentary: I see a lot of things that I definitely am not. I see power tools, which I guess are supposed to represent how men like to build things. *I don't.* I see a lot of muscular men and things that would get you to be muscular and I guess I would like to be more built but I don't agree that a person's build or physical strength should define him. I see men who are sleeping. A lot of the time men are called lazy and I also don't agree with this. Gender has absolutely nothing to do with being lazy. Completely stereotypical. I see beer. Men are supposed to worship beer and I don't see why. Frankly I [would] rather have mango juice. I see a lot about sports (more of sports that involve balls). I personally am scared of balls because as a child I was always hit and my glasses always seemed to break because of some type of ball hitting me.

Figure 4.4

Female commentary: I think that if I were a guy, I'd find living up to the attention-seeking jock stereotype difficult. I...would have crushes like anyone else, but I wouldn't be able to compete for all the girls and look the hottest.

Bringing it all together

Gender roles and expectations can be positive, neutral, or negative, but when they trap us in predictable and repetitive behaviors, they can act against us. Over the past 50 years, gender role expectations about women have opened up considerably. Women can now be physically active and sexually assertive, hold positions of power, and take risks without necessarily being considered unfeminine. There is still undue pressure on women to be physically attractive and desirable to men (if you don't believe this, just look at the advertisements on TV or in magazines), but in general, women have more access to a greater variety of

roles than they did decades ago. Men, on the other hand, have not seen an equivalent growth in their ability to show non-stereotypical behavior. Men who are househusbands, show vulnerable feelings easily, don't take charge, or don't know how to operate complicated machinery are often ridiculed and ostracized. One of the ironies of gender role stereotypes is that men are seen as autonomous and self-reliant figures, yet are bound by stereotypes of what a "manly" man should be.

Throughout this chapter we have looked at ways in which cultural expectations and stereotypes about gender may affect how we view ourselves and others. As you go through your life, it is worth asking yourself the question: am I doing what I really want to be doing, or am I acting in a way that stems from a gender stereotype I feel obligated to fulfill? For fun you might try acting in a way which your culture might label as something appropriate for the other gender. For example, women might try lifting weights and men might try wearing high heels. As you read this last sentence, you will probably think lifting weights for women is acceptable, but wearing high heels for men is not. Can you think of examples where you do something typically associated with the other gender? What happens if you do this? What you may find is that men are actually more restricted in their range of behavior than women, a finding which is perhaps at odds with the general societal consensus that men have more freedom than women. What does this tell you about freedom of choice for men and women in today's world and how might it change the way you lead your life on a daily basis?

As you consider the impact of your gender, think about how it affected the roles you played within your family of origin, and what this meant for you growing up. Based on the examples given in Exercise 2 (Reverse gender autobiography), it seems that girls are typically under more constraints in a family environment than boys, and that men hold greater value and power in their families than women. With this in mind, think about yourself right now. Do you value one gender more than the other? Do you think you would have had an easier, more fulfilling childhood if you had been born as the other gender? If you are a parent, do you think you give your children of both genders equal access to opportunities?

Stereotypes about gender as shown in the popular media have a strong impact on how we view ourselves. Consider how much you like

or dislike these stereotypes. As you look around you, do you see examples of those stereotypes in action? If so, what can you do, as one individual, to move beyond restrictive expectations? You might try making a list of gender-role stereotypes and then seeing how those play out around you in the course of a week. Where do they show up most often or least often? What happens to individuals who violate those precepts? Think about how you might change your own behavior to confront stereotypes which get in the way of being true to yourself and doing what you want.

In keeping with the idea of the value of self-exploration, take time to examine how you handle the stereotypes and expectations about your own gender that your family and culture have handed to you. Emotionally healthy people have the ability to take on different roles and behaviors. Men and women, therefore, should be able to exhibit a range of behaviors in accordance with what they want, not what society expects. The goal of self-exploration is to open up possibilities and to gain perspective on who you are, have been, and could be. Stepping outside the confines of gender expectations is one way to explore those possibilities.

CHAPTER

5

Race
and Ethnicity

Overview

People hold many diverse perspectives about race and ethnicity, but no one would dispute that our racial and ethnic backgrounds play an important role in defining our personal identities. We are all born with certain racial characteristics and into a particular ethnic background. One dictionary defines a race as "a local geographic or global human population distinguished as a more or less distinct group by genetically transmitted physical characteristics" (American Heritage College Dictionary 2004, p.1146). Because these characteristics are often external, race is usually something we can identify from someone's skin color, hair texture, facial features, or body build. Ethnicity, on the other hand, relates primarily to social patterns. The dictionary definition of ethnic is "relating to a sizable group of people sharing a common and distinctive racial, national, religious, linguistic, or cultural heritage" (p.480). Ethnicity, the affiliation to a particular ethnic group, is harder to detect on the surface since it includes traits such as religion and culture which may not be immediately evident from a person's physical appearance. It is also a broad category which includes a number of dimensions, unlike the definition of race above, which is specifically linked to inherited physical traits.

Views of race and ethnicity (and definitions and classification systems) vary from culture to culture and from one country to another.

For example, Brazil has many more racial categories than the United States. In the *US Census of Population and Housing* (Bureau of the Census 2000), 63 combinations of six basic categories are used to describe the racial makeup of Americans. In contrast, Brazilians use more than 300 different terms to designate skin color, and racially mixed relationships are considered the norm (Rother 2003). The result is that racial categories in Brazil have never been defined as they were in other more segregated countries. In Haiti, the concept of "white" has a broader definition. Having any amount of white ancestry, not visible skin color, may be the defining factor in this categorization. These diverse definitions underscore the reality that concepts of race and ethnicity vary depending upon the larger national and geopolitical context. Seen from this viewpoint, race and ethnicity are socially constructed ideas that people use to define themselves in contrast to others. An individual can be part of a minority in a particular culture, a role that underscores the difference between that person and his or her immediate world. Placed in an environment where the same person is in the majority, the issues shift.

As the world's population has grown and the popular media has transcended geographic barriers, the ability to remain isolated from people of other backgrounds and beliefs has greatly diminished. In countries like the United States, the blending of diverse cultures is common, particularly in urban centers where in general people have greater exposure to a range of ethnicities. Although many people desire to hold fast to their unique cultural inheritance by choosing to associate primarily with others who share a common ethnic and racial background, some people prefer to assimilate and become part of a blended culture. This blending can include exploring and adopting other ethnic traditions, marrying outside of one's faith or race, and creating families where the children inherit diverse traits and traditions from both parents. Still others have a foot in both worlds, maintaining their strong cultural ties while functioning effectively in the mainstream.

Blending of race and ethnicity can lead to a blurring of identity. If you come from a multi-ethnic or multi-racial background, how does that influence your sense of self? What does it mean to be you in the context of your race and ethnicity? How does your self image vary from the view others with different backgrounds have of you? How do

these points of view change depending on whether you are part of a majority or minority?

As young children, we often learn about both favorable and unfavorable stereotypes relating to racial and ethnic groups well before we have the maturity to understand the full implications of such views. By the time we reach maturity, those stereotypes have worked their way into our world view and can unconsciously influence the way we make decisions and understand ourselves and others. If those views are negative, we can end up viewing ourselves in a negative light without realizing that this is not our view, but comes from someone else. Thus, we don't always take the time to carefully examine who we are as a result of this background.

The exercises that follow touch on views of race and ethnicity, both from your own vantage point and from the perspective that others have about you. As you do these exercises, take note of how they make you feel about your own identity. As an empathetic experiment, imagine how others from different ethnic and racial backgrounds might view the same exercises.

Exercise 1: Family tree

Purpose: To explore the ethnic and racial makeup of your family background; to identify pieces that may be missing from your understanding of your family's ethnic and racial history.

Materials needed: 8 ½ x 11 inch blank paper, pens, crayons.

Instructions:

1. Draw your family tree, including your parents and grandparents. Indicate your parents' and grandparents' names (and maiden names if applicable), their racial and ethnic background, where they were born, where they grew up, and whether they are deceased. If families are blended (i.e. step-parents, adopted children, etc.), this should be indicated on the chart.

2. Once you have finished, write down the greatest gift and the greatest disadvantage you have received because of your racial and ethnic background, and what you find to be the most interesting aspect of your family tree.

3. Put a picture of yourself at the bottom of that tree, describing your own information (your name, birthplace, where you grew up, your ethnic and racial background). If you feel comfortable, you might want to consider sending a copy of this tree to your family members, especially if information is missing.

Additional instructions for groups:

Time frame: 50 minutes

1. Draw family trees as per instructions for individuals. **(15 minutes)**

2. Write down the greatest gift and the greatest disadvantage you have received because of your racial and ethnic background, and the most interesting aspect of your family tree. **(10 minutes)**

3. In round robin fashion, take turns passing around your trees and telling others about the gifts and disadvantages of your families, and the most interesting aspects of your trees. **(25 minutes)**

Questions to consider:

- What is your ethnic background? Do you identify with a single or multiple ethnicity?

- What information is missing from your family tree? If there are blanks in your tree, do you know why the information is missing?

- How might you go about finding out that missing information?

▶ Example 1: Lloyd's family tree

Maternal Grandparents

Anzley Morrell—deceased
b. Eufaula, Alabama
Grew up in Detroit, MI
African American

Concetta Coulter—deceased
b. Lexington, KY
Grew up in Detroit, MI
African American

Paternal Grandparents

Harry Johnson—deceased
b. Chatham, Ontario, Canada
Grew up in Canada and Detroit, MI
African American

Olympia Wilkins—deceased
b. Norfolk, VA
Grew up in Norfolk and Detroit, MI
African American and Native American

Mother
Minnie I. Morrell—deceased
b. Detroit, MI
Grew up in Detroit
African American

Father
Alexander Johnson
b. Detroit, MI
Grew up in Detroit
African American

Sibling
Alexia P. Johnson—deceased
b. Detroit, MI
Grew up in Detroit, MI
African American

Lloyd Sheldon Johnson
b. Detroit, MI
Grew up in Detroit, MI
African American

Figure 5.1

The greatest gifts I have received because of my racial and ethnic background are resilience and persistence. Growing up in Detroit with parents who were both born and raised in the same city, I was taught at an early age that I would need to be strong, educated, and committed if I was going to find the happiness and success in life that I desired. My race and ethnicity informed my life strategies because I was ever mindful of the existence of racism; I made a commitment to social justice at an early age. I think that religion and spirituality were also special gifts because they provided the powerful foundation from which resilience and persistence emerged.

The greatest disadvantage I experienced because of my race and ethnicity has been the denial of equal rights and access to the benefits of this society and culture because I do not have "white skin privilege." I am not lamenting this nor am I suggesting that I would have preferred to have been born white; I am simply pointing out the reality we face as "brown" people in North American society.

The most interesting aspect of this family tree is the migration of my ancestors from different parts of the country to a place where they felt they would be able to survive and flourish. It is also interesting that I can identify some aspects of Native American culture in my family history. However, the African American presence has been the dominant social and cultural influence.

▷ Example 2: Jessica's family tree

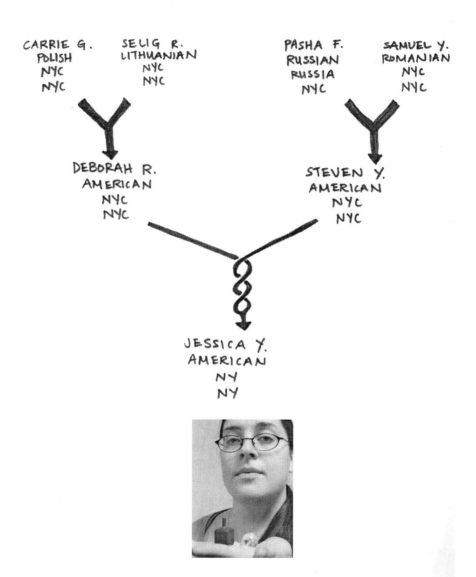

CARRIE G.
POLISH
NYC
NYC

SELIG R.
LITHUANIAN
NYC
NYC

PASHA F.
RUSSIAN
RUSSIA
NYC

SAMUEL Y.
ROMANIAN
NYC
NYC

DEBORAH R.
AMERICAN
NYC
NYC

STEVEN Y.
AMERICAN
NYC
NYC

JESSICA Y.
AMERICAN
NY
NY

Figure 5.2

Greatest gift
An awareness of myself and my world…as I move into my future as a product of my past: a member of both the majority (Caucasian) and minority (Jewish).

Disadvantage
The constant struggle of how to label myself, and what to share of myself.

Most interesting aspect
You can't see it because the first letter stayed the same, but my paternal grandfather changed his [very ethnic] last name to a vaguer, more common American name. He was unable to find work as a Jew in America, and thought changing his name might help. It did, but at the cost of denial. Seeing the names reminds me of this past—which is part of my past—of all I have to be thankful for, and keep working toward.

Exercise 2: Cultural objects

Purpose: To identify with your own culture or ethnicity through a tangible object of significance.

Materials needed: A camera, pen and paper or computer.

Instructions:

1. Choose an object that holds a special cultural or ethnic significance for you.

2. Take a photograph of the object.

3. Make a copy of your photograph. Beneath the photo, title your object and write a paragraph or two about why that object is special to you and what it says about the values of your culture.

Additional instructions for groups:

Time frame: 60 minutes

1. Bring an object from home that holds a special cultural or ethnic significance for you. Write a paragraph about why that object is special to you and what it says about the values of your culture. **(5 minutes)**

2. Place your personal objects in the middle of the group. Select an object about which you don't know a great deal. **(5 minutes)**

3. On an index card, write down what you think might be the correct answers to the following questions for the object you selected: **(5 minutes)**

 ○ What is the object?

 ○ What does the object represent about culture or ethnicity?

 ○ Is this item functional or symbolic (or both)?

 ○ Is the item a daily part of the owner's life, or is it used only on special occasions?

4. Share your thoughts about the item you chose with the large group. After each person shares, talk briefly about the personal significance of your own object. **(45 minutes)**

Questions to consider:

• Was it difficult to come up with a single object that was somehow representative of your culture? Why, or why not?

• What did the object you selected teach you about yourself and your values?

• If done in a group context, were there any surprises about how someone else interpreted your object?

▷ **Example: Boi-bumba**

The boi-bumba is a ceramic representation of a native costume of Brazil. This costume is used in traditional festivals of Brazil and represents one man underneath the costume of an ox which is colorfully decorated. Back in the eighteenth century, the boi-bumba reflected the social difference between black slaves, native Indians, and the owners of the big plantations. As the popularity of boi-bumba spread across the country, it assimilated other cultures, costumes and meanings. For instance, the clothing of the ox is presented in three major colors (red, blue and green) which are clearly an influence of the Portuguese Jesuit priests.

 To me, the boi-bumba represents this huge melting pot that Brazil is today—that I am. It represents a country that is more

Figure 5.3

tolerant of races, a country that prides itself for being "exotic" and diverse. Not to say that there isn't any racism. But it is a society that is very open and that embraces an ever growing cultural diversity.

Exercise 3: Racial and ethnic stereotypes

Purpose: To examine how stereotypes about your race and ethnicity have had an impact on you and your sense of self.

Materials needed: Paper and pen or computer.

Instructions:

1. Answer the following questions:

 o I am a (your race) (your ethnic background).

 o The stereotypes about me as a . (your race) . (your ethnic background) are the following (list as many as apply):

 o What is most helpful to me about these stereotypes?

 o What is most harmful to me about these stereotypes?

o How have these stereotypes affected my life?

2. If you would like to gain perspective on your experience of stereo-types, do this exercise with a friend of a different racial or ethnic background and discuss how your lists are similar or different.

Additional instructions for groups:

Time frame: 90 minutes

1. Write down the answers to the questionnaire above, responding to each question on a separate index card. **(10 minutes)**

2. Pair up with someone of a different racial and ethnic background (if possible) and share answers. **(10 minutes)**

3. Reconvene in the larger group and give your index cards to one person who reads answers for each question, with a short discus-sion following each set of questions. **(45 minutes)**

4. Finish the exercise by thinking of an incident in your life where there was some misunderstanding due to racial or ethnic stereo-types. Write down the circumstances of that incident, and think of one way to handle the incident more effectively. Share answers with the group. **(25 minutes)**

Questions to consider:

* How common are the stereotypes that you listed?

* Where do you believe you learned these stereotypes?

▶ **Example 1: Jose**
I am a Hispanic Puerto Rican. The stereotypes about me as a Hispanic Puerto Rican are the following:

* all guys are "macho"

* get drunk all the time

* they're not civilized

* don't do any work

* not honest

* don't go to meetings on time (irresponsible)

- loud

- messy

- like to steal (criminal)

- have kids before finishing school

- all Hispanics in the US are Mexican

- maid, cleaning person

- live with extended family and have lots of kids

- knows how to dance salsa well

- not smart.

I would say that no stereotype is really helpful to me since I would like society to give me a chance to define myself rather than being pre-judged by stereotypes. The fact that I walk into a room and all someone sees is a Hispanic person, and thinks they know what to expect from me automatically, is very frustrating and harmful at times. Even what would be considered a "positive" stereotype, for example that we know how to dance salsa, puts Hispanic people who don't know how to dance in an awkward position at times.

I feel like all stereotypes are harmful to a degree. However, the stereotypes that have affected me personally the most would be that Hispanic people are not smart and don't like to do work. Although this is not a frequent problem, it is something that I hear from others, and sometimes, even if someone doesn't explicitly say it, you feel obligated to act as if you can do many things by yourself in order to break with the stereotype. This is very harmful when you're trying to learn and figure things out in a college environment.

▶ Example 2: Althea

I am an African American. The stereotypes about me as an African American are the following:

- I am loud.

- I am aggressive.

- I am not as educated as the average white person.

- I am ignorant.

- I am sexually promiscuous.

- I do not speak proper English.

- I know how to dance.

- I could easily be an entertainer (basketball and football player, rapper, model), but not a professional (doctor, lawyer, engineer, professor).

As an African-American woman, the following stereotypes can be added:

- I have a large butt, wide hips, and big lips.

- I cook fried chicken often and eat unhealthily.

- I am either the "Mammy" figure from "Gone with the Wind" or very promiscuous, but never anything in between.

These stereotypes are very rarely helpful, although they do tend to highlight some of the aspects of my culture that are entirely different from the mainstream white culture. For example, dancing, making music, and singing are in fact huge parts of my culture, because a large part of my community is centered around the African-American church which serves as both a religious institution and a social organization. Dating back to the days of slavery, the African-American church served as a place where enslaved black people could congregate, unify as an oppressed people and even secretly worship their own gods. Dancing, singing, and making music became incorporated into this institution simply because there was no other place to do it. In this respect, these activities have become like a second nature to a lot of black people. However, we must always remember that cultural attributes are not necessarily individual ones, and so this stereotype also has the potential to be hurtful and alienating.

These stereotypes can be harmful to me because they can hinder my progress in society. I am less likely to be hired for competitive positions if the person hiring feels that I am more likely to be loud, aggressive, ignorant, or sexually promiscuous in a professional setting. Stereotypes can also be perpetuated by members of

my own community. There are black people who purposefully exploit the sexuality of black women to make money, and thus promote the stereotype of the sexually promiscuous black woman. There are also those who automatically see white people as the smarter race because they have been taught, either by their own culture or society, to believe that blacks are not as smart.

These stereotypes have affected my life and the lives of many other educated African Americans in serious ways. In order to debunk the stereotypes listed above, I and many of my black peers adopt alternate personalities and behaviors depending on our environment. This phenomenon is called code-switching, and involves changing personal attributes such as one's language/word choice, style of dress, tone of conversation, and style of conversation. When around non-black people, I am more likely to speak proper English, dress in a more conservative manner, speak more quietly and with fewer intonations, and try to appear like I am completely accustomed to mainstream white culture. This behavior allows me to appear less threatening to the non-black people that I interact with, and in turn, makes them more likely to incorporate me into their circle/lives (whether this be institutional circles, friendship circles, or classmate circles) without the construction of a racial barrier. Overall, this strategy serves to both allow for my progression through a society that is culturally "white" and teach others that black people do not necessarily fit the stereotypes that are imposed on them.

Althea's comments about the experience of doing this exercise with someone else (Wilza):

When I did this exercise with Wilza, a young woman of Brazilian descent, I learned that we had actually shared quite a few similar experiences, although our backgrounds, physical appearances, and histories were completely different. We both identified with being a minority in a country that is largely white, and shared common feelings of alienation and powerlessness. She talked about how she had never really been aware of her race until she started living in the United States, and then seemed amazed when I told her that as a black person, my race largely defines me. I cannot think about my past, present or future without

acknowledging the overwhelming contribution of my race. Her experiences and increased recent awareness of her own racial identity reaffirmed my belief that the United States was and still is constructed on the idea of racial differences, separations, and stereotypes. We even wondered what the United States would be like if it really did become a melting pot, and everybody identified themselves not by their race, but by their national identity (or more likely, their social status). My experiences as a black person would have been completely different, and I suddenly understood how different her experiences in Brazil were compared to mine. Overall, our completely different backgrounds had somehow converged on the front of racism, intolerance, and institutionalized oppression, and I was able to create a very personal bond with someone I had only met an hour earlier.

Wilza's comments about doing this exercise with Althea:
I am still thinking about the conversation I had with Althea. Throughout the conversation I could empathize and understand the aspects of racial and ethnic prejudice that Althea has gone through, some I have gone through myself. However, there are differences between the two of us. I had never thought or felt like a minority until I moved into the United States, but Althea was born in a country where her color makes her part of a minority group. So, most of the time I forget that I am a minority and don't think about it, until I am reminded by filling out a form where "race/ethnicity" is required, or by an unfortunate situation. To Althea, it is part of who she is.

My physical features do blend in in most developed countries and certainly in most developing countries, like a chameleon. It's not until people hear my accent that I become "different." In Althea's case, her skin color is already an identity. As she herself said, she fears going to certain parts of town at night, where she was told it could be dangerous for her. It saddens me, but I do understand her.

We both agree that the only way to diminish the gap between racial and ethnic groups is through education, through being a role model to peers. However, one of the things that really marked my conversation with Althea was when she said that her community expects her to give back. Once she achieves a higher ground, she is expected to give back. I thought: wow! that's a lot of responsibility and a lot to carry on your

shoulders. I don't feel any obligation towards my communities (Latino or Brazilian), maybe because I was born in Brazil. Maybe a Latino born in the US feels the same as Althea does, I really don't know, but I doubt it. I do personally want to become an outstanding person and be a good representative of my country of origin. The way I see it, the best way to help anyone is to help oneself. If I am able to achieve great things and become a role model, others will mirror my actions because I believe that people learn by example. I don't have a target group in mind—I mean people in general.

 Example 3: Steve

I am a white Jewish male. My initial description of my ethnic background was "Jew." In trying to answer the questions below I decided to modify that to "Jewish male." While neither Jew nor male is strictly speaking an ethnicity, both often operate like ethnic categories for the purposes of stereotyping. The fluid nature of these descriptions is seen in the fact that less than two generations ago "Jew" would have been viewed as a racial category.

Jewish self-stereotypes
Academic and cultural achievers, concerned with doing good in this life (there is no next one), pushy women, wimpy men, not joiners, lower rates of alcohol abuse and domestic violence, always in danger of anti-Semitism.

Jewish external-stereotypes
Academic achievers, loud (especially NY Jews), nouveau-riche (with its derogatory connotations—think *Goodbye Columbus*), powerful political lobby, disproportionate power in the media and banking.

Jewish Philip Roth-stereotypes
Mama's boys, all of the above doubled plus sex.

Being described and categorized reminds me that my life is not necessarily normative (and as such beyond categorization) while other groups are marginal. I allow myself to view my social position as luck—and I'm not voluntarily giving it up any time soon—but not because I'm somehow better or more deserving than those less lucky. The positive Jewish self-stereotypes are really

about a set of values that shaped and continue to shape my life in positive ways.

I've never felt directly harmed by anti-Semitic stereotypes. There have been instances where I've considered whether or not to "come out" as Jewish and I suppose just having to worry about it is in some ways corrosive. It's never turned out to be a problem.

Bringing it all together

To begin exploring our racial and ethnic identities, we must first identify what we believe our racial and ethnic background to be. Although this may seem like a simple task, we may discover when looking back on our family origins that we are missing important details that can affect our sense of racial or ethnic identity. How did our parents and grandparents think of their own race and ethnicity? Might they have perceived this part of their identity differently than we do? What factors played a role in how they viewed their race and ethnicity? Was their country of origin the same as their children's? Were they part of a majority or minority? How has the social and political climate changed from when they were our age? Can understanding more about our ancestry change our perception of who we are?

Many people lose family members before they have had a chance to get a clear picture of what that person's life was really about. Once family members have died, it becomes much more difficult to find out that information. As you go forward with your life, consider ways that you might collect information about your parents, grandparents, and other important family members—through existing letters, documents, images, and electronic media, for instance. You can also take an oral history from living family members, either recording or making written notes about their lives and their experiences of the world from a time before you were born.

Our environment has a large impact on our sense of self. In our living spaces, we tend to surround ourselves with objects that reflect our identities. Cultural or sacred objects, in particular, can signify inherited traditions that become a focus for our cultural and ethnic legacies. You can keep an inventory of objects in your life that have such associations for you. Think about how an outsider might view these objects.

What ethnic symbols or icons from other cultures seem most foreign to you?

If you come from a minority background that has exposed you to prejudice or social disadvantages, take note of the kind of role models available to you and how they can serve as inspirations. Consider also how you can serve as a role model for others. When examining racial and ethnic stereotypes, think about ways to identify prejudice and deal with it constructively in yourself and others. Ask yourself periodically whether you are leading the life you want, or whether you are following other people's expectations, based on their perceptions of your racial makeup.

As you continue through the following chapters, think about how ideas about race and ethnicity interact with other aspects of your identity: the roles you play, your core values, yourself in the context of world history, and ways of perceiving yourself in the future. People close to us can influence our views so strongly that it becomes difficult to differentiate our personal experiences from those of our families, friends, and mentors. Try to clarify in your mind which of your opinions about race and ethnicity are inherited and which have arisen from your own experiences. Whatever you do or become in your life, your race and ethnicity will play a role. They are part of your inheritance and your legacy to others. How well you understand the place of race and ethnicity in your life will determine in important ways how you interact with society at large.

CHAPTER

Self in Historical Context

Overview

This chapter focuses on understanding who we are within an historical context, both past and present. Earlier in this book, we looked at how our family and personal history shaped who we are and what we would like to become. In this section, we will explore how history outside of our immediate circumstances can affect our lives. We will call this "world history" to distinguish it from personal history (things that happened to us) or family history (things that happened to our families, including events that extend back many generations but still have an influence on us). In our definition, world history would include any significant local, national, or international event. This is an important part of self-exploration and one that may be left out in self-analysis.

Often it is difficult to tease out what we consider to be our own personal history from that of the larger world around us. On some level, all history is personal because we learn about it through our own eyes, with our own interpretations, beliefs, and prejudices. With this in mind, it is important to come up with a definition that clearly distinguishes larger world histories from our own personal ones. One way to look at it is to say that world-historical events have a serious impact on a large number of people or a lasting effect over time.

Understanding something of the world outside us is one of the key elements in a greater understanding of ourselves. Our immediate

sphere of influence (such as our families, friends, school, job, and day-to-day activities) is one of the primary contexts for self-understanding, but what about the bigger picture? Larger events can turn out to be personal if they have a direct or indirect effect on our lives. For example, many people have immigrated to the United States over the decades to avoid wars or economic disasters that threatened their lives or livelihoods. In this way, a war is both world history (part of the larger constellation of world events) and also part of their personal histories. World history can also have an impact on us through our family members. For example, perhaps it was our parents or grandparents who immigrated. Their experiences probably changed them in fundamental ways, in turn changing the way we related to them growing up and the values we hold. In this context, world events that we did not personally experience nonetheless shape our daily lives.

Think about your life for a moment. What local, national, or world events might be affecting you right now? Do you live in a small town or a big city? What has happened in those areas in your lifetime that might have changed your own experiences of those places? Natural disasters? Local economic problems? What country do you live in? What has happened on a national level that has affected you? Does your age determine which events you deem to be historically significant? What about world events such as World War II, the Vietnam War, or the wars in the Middle East? Did you serve in one of those wars or know someone who did?

In the process of self-exploration, self in historical context is too often left unexamined. Understanding ourselves as people enmeshed in an historical context is important in clearly seeing who we are. The following exercises will give you perspective on how history has shaped who you are and help you see the many tendrils that connect you to your historical context.

Exercise 1: Visualizing yourself in historical context

Purpose: To see how important historical events have had an influence on you; to create an image of yourself in the context of history or an ongoing social, economic, or political event.

Materials needed: Camera, pen and paper or computer.

Instructions:

1. Research an historical event that occurred at a specific location or has been memorialized in a place where you will be able to take a photograph of yourself. As an alternative, you can research an upcoming local event where you will be able to take a photograph of yourself. This can be done by reading news items about a planned event (such as a rally or demonstration), an important public ceremony, or a political event—in short, any event that will have an impact on a larger group of people that is deemed newsworthy.

2. Take several photographs of yourself in the context of either a current or an historical event. There are a number of ways to do this. For example, take a self-portrait in front of a monument or memorial, or in a place where a particular important event has occurred (such as a battleground, or a famous plaza or building). Think about how you might want to appear in this photograph in relation to the space. You might want to organize your self-portrait in a way that reflects your feelings about the event. This might be done by thinking about your camera angle; considering where you place yourself in relationship to the monument, building, plaza, etc.; or choosing a particular facial expression or mode of dress. Play with the possibilities. Use this photograph as an opportunity to express your feelings about the event in question.

3. Write about the photo you have taken and why this particular historical or current event has personal importance to you. How do you feel looking at the photo? What kind of message does it have for you? Has your view of this particular event changed through the process of photographing yourself in context of this event? Did you learn something new by attending the event or reading a plaque at the historical site? You may want to refer back to original source materials (news articles, essays, etc. you have collected) to see whether and how your views have changed or been clarified through the self-portrait process.

Additional instructions for groups:

Time frame: 45 minutes

1. Take turns sharing your photographs and discuss why you chose that particular historical or current event to focus on. **(30 minutes)**

2. Discuss what it means to view yourselves in an historical context. **(15 minutes)**

Questions to consider:

* What are some of the tools you might use to understand yourself better in an historical context? News articles? Images? Recordings? Artifacts?

* Do you know people (for example, parents, grandparents, teachers, mentors, and bosses) who can open a door to connect you with a greater history?

▷ **Example: Holocaust memorial**

The first time I can remember being introduced to the Holocaust was in fifth or sixth grade in English. We read a book that was about a boy in the Holocaust. It really went deep for me and has always stuck with me.

The historical event that has always been closest to me is the Japanese internment because I had relatives involved in it. Through it many things have been imprinted on me. I have learned that humans have done some truly atrocious things in history, equality and tolerance are values that are not always respected as they should be respected, and the dark sections of history are often forgotten. I can remember one time hearing that there are people who don't believe that the Holocaust happened, despite all of the first-hand accounts and evidence everywhere. If people can deny something this immense, how easy is it to forget the smaller things? If they forget, they can let it happen again, and that scares me. I guess because I had relatives that were discriminated against, equal rights have always struck close to home. I can't even begin to explain how important it is to me that the Holocaust is remembered.

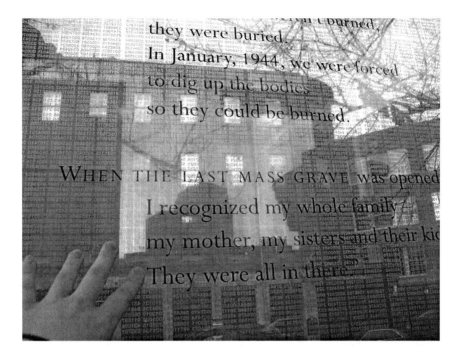

they were buried.
In January, 1944, we were forced
to dig up the bodies
so they could be burned.

WHEN THE LAST MASS GRAVE was opened
I recognized my whole family:
my mother, my sisters and their kid
They were all in there.

Figure 6.1

One of my closest friends is Jewish. Her family survived the Holo-caust, barely. She has a truly amazing account of survival to tell about her family. How many other similar stories are out there? Each one is unique, and yet each one has the same horrific theme. You could almost say that I am almost fascinated by the blackest parts of history, the biggest injustices, and the most pain. In a sense I am, but I think it relates more to me wanting to make the world a better place. I've always felt that through memory alone a lot can be prevented. Also, though every one of these stories is sad and depressing, in each is a resounding theme of human spirit and endurance which is uplifting. They make the hard times more bearable. They attest to the human struggle and the vast amount that humans can suffer, and they make my trials seem miniscule.

This particular memorial is located on the freedom trail in Boston near Haymarket. The first time I saw it was near the begin-ning of last semester. I remember thinking at the time that it was kind of odd. I didn't realize what it was until later. Today was the

first time that I've ever really looked at it. I was expecting to go and just take the picture and leave, but I ended up spending quite a bit of time just reading the quotes and soaking up the memorial. I found it really powerful. I chose the quote in the picture because that one affected me the most. The amount of cruelty, pain and tears portrayed in the simple sculpture is incredible. I must admit, I was in awe. All of the people in the area just walking around, going about their lives, really struck me too. I wondered how many of them had ever really looked at the memorial and how many of them pass it every day, but have no idea what any of it reads. Although I was amongst many people, for a moment, I felt isolated; I only shared the pain I felt with those long ago affected by the Holocaust.

I chose to take the picture showing only my hand for the obvious logistic reasons, but also because it seemed right. I felt that the focus should lie with the memorial itself, and the use of a hand touching it represents the connection I felt to it when I visited the memorial.

Exercise 2: Switching places

Purpose: To give you a sense of what it is like to be part of a newsworthy or historic event; to offer a perspective of being in someone else's shoes.

Materials needed: Current newspapers or periodicals, word processor.

Instructions:

1. Clip a news article about a current event. You can choose any event you like, but draw it from a major recognized news source such as the *New York Times* or CNN. It is easiest if you can copy an electronic version of the article and place it in a word processing program that has a global "search and replace" feature.

2. Replace one of the key players in the article with yourself. If the gender is different from your own, be sure to change all relevant pronouns.

3. Answer the following questions:

- What does it feel like to see your name in print in context of this particular story?

- Why did you choose this person to replace in the article?

Additional instructions for groups:

Time frame: 45 minutes

1. Make enough copies of the new article to distribute to members of the group.

2. Break into triads. Read each article aloud and discuss how it feels to be that character in the article. Discuss why you chose to switch places with the person you did. In what ways is he or she a reflection of who you want to be or don't want to be? **(30 minutes)**

3. Reconvene in the large group. Discuss what it felt like to read your story aloud. **(15 minutes)**

Questions to consider:

- How different is this person's life from your own?

- Is there any part of this person's life that you would like to emulate?

▶ **Example 1: Pamela Obama speaks with MSNBC**

Pamela Obama discusses family, work, and life on the campaign trail

Earlier today on "Morning Joe," MSNBC aired an interview with Pamela Obama, the wife of Democratic presidential candidate Barack Obama.

Below is a transcript of the interview that aired this morning on "Morning Joe."

MSNBC anchor: "Pamela Obama, thank you so much. How did your husband do last night?"

Pamela Obama: "Oh, he was awesome. Yeah, he was wonderful. It was Barack in his essence. He was comfortable, confident, you know, the measure of how I think he does is how I feel. And I was moved. I listen very intently when he speaks because I always want to find out whether I believe it, you know, whether I feel that authenticity. And I do every single time he speaks, but there are just

some times when he touches my heart in a way that makes me very clear about why we're doing this."

MSNBC anchor: "I'd like to ask you about the status of your career at this point. Because you've cut back if I've read correctly, to 20 percent of your job."

Pamela Obama: "Yeah, I mean, you know how work is for mothers. It's all very flexible. I carry a Blackberry from work, so I'm constantly on that, in communication with my assistants, my staff, and with today's technology you can do a lot over Blackberry… I'm not in there every day, but if somebody needs me, if they have a question, I'm certainly not gonna say, 'don't ever call me again, we're running for president'. So it turns out that, you know, I, you know, focus on it when needed. And again, I don't think that's very different from what a lot of women do. We are always juggling. I don't want to pretend like this isn't any different, but I have spent my entire adult life, as a professional, as a mother, juggling. Balancing so many different hats and personalities that I sorta add one more on there, it's like, okay, I can do that too."

Author's comments:
I chose Michelle Obama because I can easily relate to her feelings and style, i.e, she is not someone who particularly wants to be in the limelight, however she has agreed to put herself there for the "cause" that she believes in. Seeing my name in print in the context of this particular story was strange only because it involved becoming First Lady to the President of the United States. At the same time, it did not feel so strange to see my name in print because over the years there have been enough articles about me in the local newspapers because of my work as a doctor. I have frequently been interviewed for articles…in fact I am working on one right now for a local newspaper. In addition, because I relate so much to Michelle Obama's low key style, I found my name in this article not so foreign. I like Michelle Obama, respect her for her character and principles, and would be proud to be "mistaken" for her. The best part about being this person would be to be in a position where my high principles could influence society and perhaps illuminate the world. I wouldn't mind being the helpmate to someone with the equally strong character of Barack Obama.

Of course the hardest part would be threefold: one aspect would be maintaining some degree of privacy for my children and family life, secondly would be juggling my role as first lady with my role as a mother. Thirdly is the challenge of living under the microscope of First Lady of America. Though I think in general Michelle is well liked and respected, there will be those who will pick apart her clothes, hair style and every word that comes out of her mouth.

Example 2: Band manager gets four years in fatal club fire (adapted from an MSNBC article, 10 May 2006)

Barry Hanson pleaded guilty to role in 100 deaths in 2003 R.I. blaze

PROVIDENCE, R.I.—A former rock-band manager whose pyrotechnics caused a nightclub fire that killed 100 people—was sentenced Wednesday to four years in prison.

Barry Hanson, 29, could have gotten as much as 10 years behind bars under a deal he struck with prosecutors in February, when he pleaded guilty to 100 counts of involuntary manslaughter. He also received an 11-year suspended sentence and three years of probation.

"The greatest sentence that can be imposed upon you has been imposed upon you by yourself," Superior Court Judge Francis Darigan Jr. told Hanson, drawing sobs and groans from some of those in the courtroom.

The sentence came after two days of anguished testimony from the victims' families, who told of college graduations they would never see, grandchildren they would never hold and grief so powerful that they could not get out of bed in the morning and looked forward to death to be reunited with their loved ones.

Hanson was the tour manager for heavy metal band Great White when on 20 Feb. 2003, he lit a pyrotechnics display that ignited highly flammable foam that lined the walls and ceiling of The Station nightclub in West Warwick. The foam was used as soundproofing and was placed there by the owners after neighbors complained about noise from the club.

Many of the 100 people who were killed that night either were quickly overcome by fumes emitted by the foam or became trapped in a crush at the front door.

More than 200 others were injured in the fourth-deadliest nightclub fire in US history, and the worst fire in state history. Earlier Wednesday, Hanson's attorney, Thomas Briody, argued that his client deserved mercy—in the form of community service, with no prison time—and feels immense sorrow for his role in the blaze.

"I ask you to consider this: Barry Hanson is the only man in this tragedy to stand up and say I did something wrong," Briody said. "He's the only man to say, 'I apologize.'"

Note to readers: The name Hanson is fictitious.

Barry's comments:

Imagining my responsibility for such a devastating tragedy is disorienting. I feel as if I must rationalize my culpability to protect my sense of self-worth. I'm not a bad person, am I? The intense grief that I caused is extremely painful to hear, but I can't suffer the added shame of running from it.

I chose this person to replace in this article because I could imagine myself stumbling into his predicament. He was doing his job the way he always did it, but hadn't paid attention to the special safety considerations of this particular situation. A series of mistakes by others then compounded his error in judgment, leading to a horrible tragedy.

I imagine that this person's life (before the tragedy) was one of constant travel and change, whereas I am a person who stays near home and keeps to his habits. Of course after the tragedy, his life in prison would ironically be more like my own, except that now he would be consumed with how to recover from the grief, shame, and notoriety of the tragedy that he touched off.

I hope that I would, like this person, stand up and take responsibility for my actions without making excuses. I would, in his situation, look for any possible way to atone for the grief and loss that I had caused, to the extent that I might welcome a prison sentence.

Exercise 3: One thing that changed my world

Purpose: To explore the impact of a specific historical event on your goals, values, and world view.

Materials needed: Newspapers, periodicals, online photographs, pen and paper or computer.

Instructions:

1. Think of an historical event which has had some kind of impact on who you are, how you see yourself, or how you view the world around you.

2. Find or create a visual image which symbolizes that event. The visual image can be a photograph, a newspaper clipping, or a drawing.

3. Write about how that event affected you in terms of your values, goals, or self image, integrating the image into your essay.

Additional instructions for groups:

Time frame: 45 minutes

1. Share images with each other, explaining why you chose the event you did and how it affected you. **(30 minutes)**

2. Discuss what the group members think about the range of images displayed. What do the images say about how people view important historical events? **(15 minutes)**

▶ **Example 1: World War II**

At 16 I joined the Women's Civilian Defense Corps whose mission was to acquaint citizens to deal with possible East Coast invasions by German submarines (which did happen). We learned how to show neighbors the steps to black-out their homes, to put out incendiary bombs and identify German planes that might launch them. I was taught first aid and how to deliver babies in the field if medical help was not available. We learned Morse code and how to send emergency radio messages. I was asked to talk about my learning experiences with the Corps to women in Massachusetts defense factories and encourage them to join. I was awkward and uncertain but felt it my duty, my contribution to our part in the war. As scared as I was, I felt proud to be able to help.

I remember vividly the day that I came home to find my father crying in front of the radio. Our former Pearl Harbor home had

Figure 6.2: Pictured above is the headline from a Gloucester, Massachusetts, newspaper, saved as a memento of the wartime era. The writer of this exercise has kept this newspaper since it was printed on 10 January, 1942.

been bombed and strafed by the Japanese. Dad was crying because he was not able to be there to help his friends and fellow officers. I had never before seen him cry and the enormity of the war was suddenly a devastating thing. Up to then my understanding of what the war meant to us as US citizens had been a nebulous thing. Now it was personal.

I joined a USO entertainment troupe and sang at military installations and hospitals in MA, NH, and ME for two years. I was overwhelmed by the enthusiastic reception afforded us by the young men waiting to be shipped overseas. At a Christmas 1943 hospital program we moved down the wards, joking with patients and singing Christmas carols and popular songs of the day. A nurse asked if I would sing in a private room to a soldier who had been burned in a tank explosion in Europe. He was covered in bandages. So I sang "Silent Night" to him. When I finished he whispered, "Would you kiss me for good luck?" All I could see above the bandages was his large brown eyes as I kissed him. On the troupe's

way out of the hospital I learned that the soldier had died as we went on singing through the wards. I could hardly make it to the bus home.

I was working full time the two years I sang with the troupe and understood that I was "filling in" for a drafted man in the service who would "bump" me from my job when he returned. We girls painted our legs with fake stockings because nylons were used by the service for medical purposes. We learned to go with little or no sugar, flour, fats, and many other rationed items which were used for the war military. I wrote numerous heartfelt letters and sent packages to my boyfriend and classmates in the services during what seemed to be a very long war.

I literally grew up during World War II and was proud of my country and loyal to its core beliefs. I despised bigotry. Had I not seen young soldiers and sailors of every lineage going to possible death? I learned compassion, and the need to stand up for what I believed in and for my own personal rights. As it was for millions of people, World War II was the major turning point in my life.

Example 2: The space shuttle Challenger disaster

The explosion of the space shuttle Challenger on 28 January, 1986, was definitely one of those horrifying public events, like Pearl Harbor or the Kennedy assassination, that burned itself into the memories of millions of people. But it also changed my own life in unusually concrete ways. I was a freshman in college at the time, and I remember hearing about the accident from another student who was sitting next to me as I worked on an assignment in the computer room at the university's science center. I didn't believe him at first. But he seemed serious enough to make me nervous.

This was long before the Web, so I couldn't simply log on and check the news. So I got up and literally ran back to my dorm room to turn on the TV. I remember thinking, as I ran through campus, that it couldn't possibly be true. Didn't the engineers at NASA know enough to prevent such a disaster? But sure enough, the images of the spaceship exploding in mid-sky, sending tendrils of smoke and flames in all directions, were all over the TV news. Like many people that day, I spent hours watching the coverage unfold, including President Reagan's eloquent televised address

Figure 6.3

(the only words of his I ever agreed with!). The horror of the event was immediate for me—it was awful to imagine what the seven astronauts aboard must have experienced as the shuttle broke up, and to realize what a huge setback the disaster was for the US space program, which I had followed with zeal since I was a young boy.

But the disaster's real influence settled in only over the next several months, as the accident investigation proceeded and the chain of events that led to the explosion became clear. (A rubber O-ring in one of the solid rocket boosters, stiffened by that morning's cold weather, had failed, allowing flames to burst through, in turn causing the shuttle's main fuel tank to explode.) The accident seemed to have such an obvious and preventable cause that, for the first time in my life, I began to question NASA's competence. And on a larger level, I began to look at all technological and scientific endeavors with a much more skeptical—one might even say disillusioned and jaundiced—eye.

At the time, I happened to be in a work-study job with an X-ray astronomer at the university's Center for Astrophysics. Within days after the Challenger accident it was clear that the massive X-ray satellite that this astronomer had been helping to build, and which was scheduled to be launched on the space shuttle, would be delayed for years while NASA retrenched. This was a big professional and personal blow for him, and it affected the whole mood at the Center over the following months. This, in turn, contributed to my own growing disenchantment with the job and with my long-cherished idea of becoming an astronomer or astrophysicist. (But it must also be said that I wasn't terribly good at math, which would probably have derailed my plans eventually anyway!)

By the end of my sophomore year, less than a year and a half after the Challenger disaster, I had decided to switch majors from physics and astronomy to the history of science, a discipline where I was encouraged to think skeptically about ideas that I had previously accepted uncritically, such as "American know-how" and the inevitability of technological progress. Eventually I attended graduate school in the history of technology, wrote a doctoral thesis about the social and political effects of technological disasters, and became a technology journalist.

The Challenger explosion didn't set the whole course of my personal history, which, like anyone's, came together from many unpredictable strands. But it came at a critical moment when I was in the process of defining my own future and was (as 19-year-olds should be) highly impressionable. I think of it as a key event in my own history as well as the nation's. And the whole moment is symbolized, for me, by the iconic TV images of the exploding shuttle, its twin boosters veering crazily off course like misdirected fireworks.

Bringing it all together

Self-history is inherently limited. We can only be in one historical era at a time. Understanding the impact of world history on our own lives helps us understand both ourselves and the larger picture to which we belong. In documenting your life, it is useful to include evidence of what is happening around you so that you will have a reminder that you are always

part of a cultural and historical setting. As a way of incorporating the idea of historical influence in your life, take time now and again to rethink the exercises in this chapter. Ten years from now, you may choose to focus on a different set of events.

The exercises in this chapter are less about offering up empirical knowledge than about getting you to ask questions about yourself. By photographing yourself in an historical context, for example, you gain a solid, tangible image that squarely places you in relation to some event. Unless we have a professional life in public service, most of us tend not to think of ourselves as being recorded in this way. In your daily life, how can you be more mindful of yourself in the context of historical events? A simple method is by keeping up on current news and clipping articles of interest, and keeping an ongoing log of your thoughts and feelings about these events. What can be learned by switching places with a figure in a newspaper article and placing yourself in someone else's shoes? Are you able to understand any better what it might be like for the people being written about? Do you question the accuracy of the events depicted in the article? What effects might this article have on the interpretation of history in the future? By focusing on one historical event that changed your world, you are saying a great deal about yourself, your values and influences. Do you think that other people with a background similar to yours would have chosen the same event? In other words, is this event personal only to you, or is its impact shared by others?

It is easy to be blind to the historical and cultural influences in which we are immersed if we never step outside of them for an objective look. This is the value of traveling or living abroad or even learning another language. Stepping outside of ourselves culturally or historically gives us a better picture of who we really are, and helps us realize how much of our character or outlook is shaped by our cultural and historical circumstances. The value of this perspective cannot be underestimated, for it gives us insight into another way of being.

7

Meaning in Our Lives

Overview

When we talk about meaning in our lives, we are focused on that which gives us a sense of purpose. We all find meaning in our own ways, based on what we consider to be important. But no matter what it is that we care about, we govern our lives based on the things that we value and that give meaning to our existence. Without meaning, we have no compass, no rudder, and no set of guidelines about how to organize our lives.

Jewish psychiatrist Viktor Frankl, who was imprisoned in a concentration camp during World War II, came to believe that camp inmates who found a sense of meaning and purpose in their lives, even in the face of extreme suffering, were more likely to survive their ordeal. After he was liberated from the camp, he went on to develop a new school of psychotherapy called logotherapy. The premise of logotherapy, as Frankl explains in his book *Man's Search for Meaning* (1959), is that people who lack clear meaning and a sense of purpose are more likely to suffer from depression, anxiety, and related disorders. He believed that helping patients find or rediscover meaning in their lives was the primary mission of psychotherapy.

There are a number of areas of our lives which provide us with meaning. Some people find meaning primarily through their careers, some through their relationships, and others through their spiritual beliefs. Engaging in significant relationships with others is one of the

most fundamental ways we divine meaning for ourselves. It is because relationships have such power to infuse our lives with meaning that they often become a focal point of our identity. Family, friends, lovers, and partners all serve as reminders of our significance in the world. Without valuable people in our lives, we experience a feeling of absence, a sense that our life has lost some of its meaningfulness. It is also through relationships that we learn to give and receive love. Loving and caring for others can imbue our lives with a potent sense of purpose as important as anything else we do. Aside from these more intimate relationships, we may also experience a deep sense of purpose by helping strangers. Here again, it is the knowledge that we have helped someone, cared for someone other than ourselves, that helps give our lives value.

In a consumer society such as contemporary America, people too often equate meaning with material items which they believe will bring them happiness. How many times have you heard, "If I just owned one more car/house/stock option, I would be happy"? Happiness is a passing emotion; meaning is a concept linked to behaviors (such as working, raising a family, or going to church) which connect us to something of significance greater than ourselves. Although we can attach significance to objects, in many cases the value of these objects is in what they represent, more than in the objects themselves. Having nice or expensive items can reflect that you have a high-paying job, which in turn may reflect that you are valued for your abilities or expertise. It is this sense of making a contribution which is valued by others that can give true meaning to life; the expensive object is merely a symbol of that meaning.

What we value, and what provides meaning, will probably change as we mature and become adults with our own careers and families. The renowned psychologist Erik Erikson (1963) wrote about the different stages of development we go through, with each stage having its own tasks for finding meaning in life. For example, adolescents struggle to find their own identities, separate from yet linked to their families. This struggle often involves some conflict between what their parents want them to do and what they want to do. Each of us may find that the things we value, and what gives our lives meaning, shift over time as we go through life's experiences (college, jobs, relationships, death in our families, illness, retirement). But wherever we are in our lives, we are

guided by our search for meaning. The more we are conscious of what we find important, the better able we are to make more informed choices about what we want to do with our lives.

Exercise 1: Evidence of meaning in my life

Purpose: To examine what you do that brings meaning to your life.

Materials needed: Pen and paper or computer, camera.

Instructions:

1. List three things you do on a regular basis that have meaning for you.

2. For each item on this list, write about what you value about those items. Imagine your life without those activities, and how your life would be different.

3. Find or take a photograph that represents one of the things on your list.

4. Place the photograph next to what you have written about it. What do you feel as you look at the picture and your writing?

Additional instructions for groups:

Time frame: 30 minutes

1. Follow the instructions above, and bring your photo and writing to the group. Split into pairs and share with your partner your photo and associated writing. Tell your partner why this activity gives your life meaning and what you imagine your life would be like without it. **(10 minutes)**

2. Reconvene in the large group. Make a list of all the activities people wrote about that gave their lives meaning. What does this tell you about what people value in their lives? **(20 minutes)**

Questions to consider:

- How do you define the word "meaning"?

- Is there a connection between what you value and what you actually do in your life on a regular basis?

 Example: Evidence of meaning in Karen's life

1. *Run my private practice in psychology:* I love the autonomy of working for myself and managing the business parts as well. I value my independence and it is gratifying to help people work through the complexities of contemporary life and learn to cope with the realities of depression, anxiety and traumatic events. I would never have predicted at 20 that I would be doing this at 60 (or 50 or 40 for that matter). It helps me in my clinical work to have learned how unpredictable and surprising life can be. I was a teacher after college and never expected to be a psychologist. Now it is more my work than my identity. And though I will keep at it another five years or so, I can readily imagine retiring.

2. *Cook for my friends:* I have begun to call it "showing off" (since no one else much likes to do it!), but I love the creativity of entertaining my friends—almost always all women. I have managed to find a bright and good-humored group. We think we are very funny and entertaining! In many ways this activity is an homage to my mother who always had candles and flowers on our daily dinner table and my father whose wonderful sense of humor, quick mind, and welcoming nature made our home a favorite gathering place for their adult friends. I guess I could get used to offering them takeout...the laughter and conversation, however, I can not imagine being without. I do enjoy my solitude, so perhaps this proportion will change over time as well. I keep in close touch with two long-time friends by phone, and know those phone conversations will come to replace many face-to-face visits as I age.

3. *Travel to see my family and friends:* My two adult children are married and I have five spectacular grandchildren, ages one through five. I go see them whenever I can and wish I were not so far away. The children are just starting to talk to me on the phone, and my house has pictures of these two growing families everywhere you look! These lucky grandchildren have wonderful parents and I relish looking in on this developmental stage in my kids' lives. My mother is alive and in assisted living in another state as well, so that is another travel destina-

tion. I have struggled with my relationship with my mother over the years, even wrote my dissertation on the topic, but I am gentle and attentive with her now. I am lucky to have enough income to allow the travel—and the freedom to take off when I want to. If this were not the case, I would move immediately to be near one of these young families. (And this is the plan for retirement as well.)

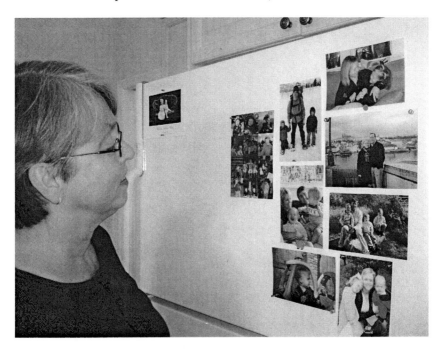

Figure 7.1

These photos are on my refrigerator. They are a changing array of pictures, right now quite a formal arrangement, and also artwork from my grandchildren. I look at them all the time. My dear friends know that nothing is more compelling to me than these young families. Both my son and my daughter have spouses who are close to their own parents, both emotionally and geographically, so they do not think it is peculiar that I love to visit! My clinical work has certainly filled the last 20 years in a challenging and stimulating way and has been the bridge over rough waters for sure, but it is not

what I'll be thinking of when I get to the next chapter in my life. (And if my mother's longevity is any measure, it will be another long one.)

Exercise 2: Expressing meaning through art and poetry

Purpose: To explore a single aspect that gives meaning to your life through different artistic methods.

Materials needed: Camera or art supplies, pen and paper or computer.

Instructions:

1. Create a visual image (using either photography or drawing) of something which gives meaning to your life. This can include but is not limited to your spirituality, relationships, career, and family. What comes to mind when you think, "This makes my life worth living"?

2. Write a poem about your photo or drawing. The poem can be short or long, in verse or free form.

3. Title your poem. Write a few sentences about why you have chosen this particular idea to express. What meaning does it have for you?

Additional instructions for groups:

Time frame: 30 minutes

1. Share your poem, artwork, or photograph with someone in the group. **(10 minutes)**

2. Discuss the differences in the way poetry, artwork, and photography can describe what you find meaningful in your life. **(20 minutes)**

Questions to consider:

- Which medium best expresses what you value? Why?

- If you had done this exercise five years ago, do you think you would have focused on a different idea about what gives your life meaning?

▶ Example 1: Reel and pull

I make a circle and give it a flick.
My worries get sent to rest,
Deeper than the worm sinks.
Reel and pull. Reel and pull.

I cast again.
The mechanics of it all take over.
Separate from my thoughts, my hands continue.
Reel and pull. Reel and pull.

I cast again.
The canoe rocks with a steady beat.
The pulse of the lake reinforces my choices
As I float into euphoria.

Figure 7.2

This painting and the poem that follows it are about self-worth and success. I enjoy fishing very much, and, like a true fisherman, the

activity is not really about catching fish. It is about taking in the scenery and truly relaxing in the moment; being one with nature and being completely detached from civilization. I find it absolutely liberating to be on the water with my line in the water, not having to worry about the daily struggles of work, money, etc. However, in order for me to truly enjoy the activity to the fullest extent, I need to accomplish many things in the realm of family, careers and education. So, the simple activity of fishing is the ultimate representation of my goals. If I am able to go fishing, then it is an indication that I have succeeded in everything that I have set out to accomplish. And only then will I be able to truly relax with a line in the water.

Example 2: Autumn leaves

Figure 7.3

The leaves
Waving at me in orange and green.
The air
Humming with the vibrance of fall.

The breath
Inhaling the crisp autumn air.

The awareness
Coming from the feelings of shift.

The excitement
Stemming from the seasons of change.

This photograph and poem reflect my appreciation of the beauty of change, which is often overlooked in the things we see everyday.

Exercise 3: Insurance inventory of valued items

Purpose: To help you conceptualize what you value by looking at what you own and have in your living space.

Materials needed: Camera, pen and paper or computer.

Instructions:

1. Go to your living space and look around you. Make an inventory of ten things that you notice that you might want to include in an "insurance inventory." These items need not necessarily be of great monetary value—they can be of sentimental or symbolic value.

2. Next to each item in the list, describe where the item came from, when you got it, its dollar value (if any), and its meaning or significance to you.

3. Take a quick snapshot of each item and attach it to the description of that item.

Additional instructions for groups:
Break into pairs and give your partner your list of items and photographs. Each of you write a paragraph about what you think your partner values are, based on his or her inventory. See how your partner's description fits with your own vision of what you value.

Questions to consider:

- When you look through the objects in your living space, how do they reflect your core values?

- Which items in your living space would you be most distressed to lose and why?

- What can you surmise about someone's values from the objects in their lives?

- How do you relate to what your partner values? What kinds of commonalities and differences can you see?

▶ **Example: My valued items**

a. Photographic negatives are the visual record of my thoughts and experiences. With light, chemicals, and creativity I can put these records on display in the form of photographic prints to share my life with others. However, since negatives cannot be duplicated exactly, if they are lost or damaged then those images are forever confined to memory.
Monetary value: Priceless.

b. Electronic data may include assignments, music, and photos in addition to the many programs I use every day to make my life more organized and efficient. If that data is corrupted or phys-ically damaged before I can make the appropriate backups, there is little chance of retrieving what has been lost. Photos or electronic artwork can be lost forever, and the remaining data will take days, months, or even years to restore.
Monetary value: Priceless.

c. I own several time-capturing-machines (otherwise known as cameras), ranging in type from the small folding camera of the 1940s to a digital SLR. Each machine acts as a unique filter of the world framed by a rectangular hole and mirrors, upside down and reversed, or simply never seen, just haphazardly burned onto a strip of film which I might develop days later.
Monetary value: A total including all cameras and lenses, well over $1,000; my favorite camera (pictured) $20.00.

a.

b.

c.

d.

e.

f.

g.

h.

i.

j.

Figure 7.4

d. These molds are remnants of an art project where I placed 80 or so plaster arms on MIT's Killian Court. The original wax casts of the initial alginate molds have met their fate of broken fingers, never again to be duplicated, and the plaster arms that survived the incident have long since found their way to friends or have shattered into pieces. These rubber molds are my only proof, aside from photographs and a lone arm in my room, of the incident, and serve as a reminder of what I can accomplish with some inspiration and a little insanity.
Monetary value: $200 (for the rubber and plaster...not necessarily all at my expense).

e. My oboe is a friend that followed me through the years of band and orchestra in high school. Like my cameras, it serves as an outlet for my emotions. It's been a year or so since the last time I sat down and really played it, as playing it irregularly can lead to cracking in the wood. I hope that once I'm through the rigor of my studies, I can find the time to pick it up and play it—I do miss its sound.
Monetary value: $5,000.

f. I received this puzzle from a retired mathematician in Cambridge who was fascinated with geometric shapes, and had puzzles and complicated objects all over his house (where my parents were staying while I spent my first nights as a prefrosh at MIT). It serves as a reminder of that experience.
Monetary value: Unknown (a gift).

g. A few days before high school graduation, one of my best friends (also graduating) gave me a bowl that he had made in ceramics, one that he was very proud of. He had gotten word of my small bowl collection (which started accidentally after I came back from Uganda), and told me to keep his bowl on my desk at college as a reminder of the "good old days" when life wasn't completely stressful.
Monetary value: Unknown (a gift).

h. For a period of my life I was just a bit obsessed with this little rock band in Ireland called U2. This sketchbook is evidence of

that obsession and a constant reminder to me that I need to draw more often.

Monetary value: Priceless.

i. This little brown photographer's notebook contains all the knowledge that I've accumulated since the first time I set foot in a darkroom. It's something I can refer to whenever I want to revisit a technique I had learned in the past, and it's a place for me to write down what I will want to remember tomorrow.

Monetary value: Priceless.

j. I bought this wooden turtle at a gift shop in Uganda as a reminder of the first summer I spent there. It brings up the moments where we (a team of high school students setting up computer labs) glanced at each other and made an odd hand gesture called "the awkward turtle" when the situation got a bit uncomfortable. This gesture is made by placing your right palm on top of your left hand and spinning your thumbs wildly, resulting in a very wobbly "turtle." This wooden turtle wobbled just as awkwardly until it lost two of its feet.

Monetary value: 2,000 UGX (roughly $1.00).

Exercise 4: Friendship maps

Purpose: To explore your connections to friends and what they mean to you.

Materials needed: Large sheet of paper, art supplies such as colored papers, magic markers, stickers, paints, photographs, etc.

Instructions:

1. Using a variety of art supplies, create a visual map on a large sheet of paper explaining the relationships you have with your friends.

2. Once you have completed your friendship map, write a few paragraphs that address the following questions:

 o Why did you choose these friends?

 o What do you admire about your friends?

 o What makes these relationships meaningful?

Additional instructions for groups:

Time frame: 30 minutes

1. After you have made your friendship map, break into pairs and take turns explaining your friendship maps. **(10 minutes)**

2. Reconvene as a group. Discuss what your choice of friends says about what you value in your lives. **(20 minutes)**

Questions to consider:

* How do you define a friend?

* What is the difference between a friend and an acquaintance?

▶ **Example: Darlene's friendship map**

I decided to craft my friendship map as a reflection on how the important people in my life have shaped me. I began by writing down names on a scrap paper. As I wrote, the names naturally fell into groups—people whom I thought of together. When I thought of how they were related, it wasn't necessarily that I hung out with all of them together; some don't know each other at all, actually. I grouped friends based on their impact on my life: my thoughts, my actions, my feelings and my perspective.

Since completing the map, I've been thinking about what a friend is to me. I think in the context of my map, a friend is a person with whom I've shared my passions, and who has shared right back (in one form or another). It's someone whom I admire and respect. I've lost touch with a few people on this map, but that doesn't make their impact any less important.

What all of the friends on this map have in common is me. They have all, in their own ways, contributed to my improvement as a human being; whether intentional, noticed, or not. Some are from the same social groups (a high school youth group, a summer job, my ultimate frisbee team), most are around my age, but there's a deeper and more important connection there as well. Each person on my map is someone thoughtful, reflective, and passionate about life. They are constant teachers, inspirations, supporters and role models in their own ways.

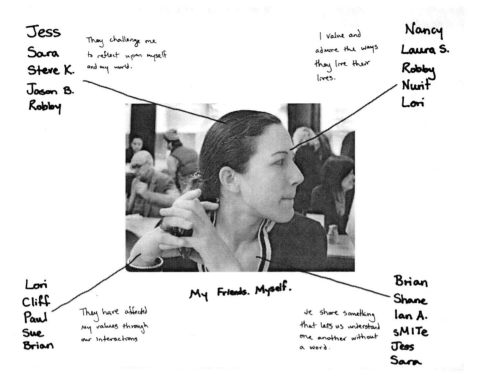

Jess
Sara
Steve K.
Jason B.
Robby

They challenge me
to reflect upon myself
and my world.

I value and
admire the ways
they live their
lives.

Nancy
Laura S.
Robby
Nurit
Lori

Lori
Cliff
Paul
Sue
Brian

They have affected
my values through
our interactions

My Friends. Myself.

Je share something
that lets us understand
one another without
a word.

Brian
Shane
Ian A.
sMITe
Jess
Sara

Figure 7.5

Bringing it all together

Determining what brings meaning to our lives is one of the most important aspects of self-exploration. We have taken you through several exercises which are worth repeating throughout your life, especially at times of transition when matters may not be as clear to you as they once were. Pause occasionally and take a moment to consider what is truly important to you, perhaps on a significant occasion such as a birthday or anniversary. These would be good times to write a poem, take a picture, or do artwork that represents what you value at that moment in time. You can also do an "insurance inventory" on a regular basis to see how what you own reflects what you value. We do this instinctively when we conduct a spring cleaning—toss out items we no longer use and organize those we do.

Consider taking photographs of things that are meaningful for you and putting them in your journal, along with written entries. Combining two or more different ways of looking at what gives your life significance can help you examine that meaning in greater depth. Take stock periodically of the important relationships in your life and think about how they imbue your life with meaning. How do these relationships reflect what you value?

Finding the time to reflect on what gives our lives meaning is something busy people don't always do. High school and college life are often crammed with homework, exams, and extracurricular activities. Most people's work lives are filled up 40 hours per week and frequently much more. Families and relationships demand our attention and often compete with our work lives for time. Looking at ourselves in a contemplative way can help us reorganize our priorities where needed and remember what is of real value in our lives.

8

Alternative Views of Self

Overview

In this chapter, you will have the chance to delve into different aspects of yourself that you may not be accustomed to revealing in your daily life. As discussed in Chapter 1, we play many different roles that express different sides of our personalities. However, we usually fall into a pattern of roles and a style of personality that is consistent from week to week. We know who we are (more or less) and we tend to act in ways that reinforce our self image. On special occasions (such as Halloween or a costume party), we can give voice to other parts of ourselves. Those of us who are serious become clowns, the sexually reserved come to the party dressed in provocative outfits, and the compassionate person dresses up as a vampire or witch. In our daily lives, however, our tendency is to stay safe with what we know.

On the occasions when we do present an alternative view of ourselves, the parts we play may shed light into corners of our personalities that we don't often explore. Psychologist Carl Jung (1970), renowned for his work in analytical psychology, called the hidden part of our personality the "shadow" self. He believed that a healthy person strives to know his or her shadow self, which is often disowned or disavowed because it is inconsistent with the common image presented to others. In Jung's theory, if we don't know that side of our personality, we remain incomplete and detached from parts of ourselves that we need to integrate. One danger of not exploring our shadow side is that we

may reject it as part of our selves, and project it on others who become "the enemy." In other words, we may vilify others by displacing our own hidden traits on to them.

Some parts of our hidden self may have qualities that, if used judiciously, can serve us well: shy people may have hidden aggressive traits that can be useful in helping them to move forward under certain circumstances. Sometimes we really want to explore a less visible side of ourselves, but won't for fear of societal expectations. For example, an outwardly strong, dominant man may want to be softer and more vulnerable in his approach to life, but could be held back by a fear of being judged as effeminate. Or a woman might want to be more bold or risk-taking, but fears being labeled as overly aggressive. Other times, we may not know how to show different sides of ourselves or even know what those sides might be.

Societal norms and expectations tend to dictate how much freedom we feel we have to explore alternative parts of ourselves. Generally, we expect children to explore fantasy as a regular part of their normal development. In their play, kids often emulate people who are entirely different from themselves. They dress up in costumes and act out a range of dramas depicting imaginary scenarios. This doesn't seem strange to us. It is a logical way for children to learn, to try out different aspects of their personalities, and to see which ones serve them best. By the time we reach adulthood, this idea of exploring our alternative selves is frequently discouraged. It is expected that we should already know who we are. However, even as adults, exploring our alternative selves in a thoughtful, measured way can be useful. It helps us to "try on" different aspects of ourselves, to play out different scenarios without risking a full-scale upheaval. You don't have to completely shift your personality in order to explore some of the more hidden parts of yourself.

The following exercises provide an opportunity for you to examine sides of yourself that you may not be familiar with, or may have let go because they didn't seem in line with your expectations. This is a chance to see what it feels like to play out a totally different side to yourself, to photograph yourself dressed as someone else, or explore a part of your personality which you don't normally show. We hope you will take some

risks with the exercises—they are designed to help you step outside yourself and the ordinary to play for a while. Have fun!

Exercise 1: Portraits without faces

Purpose: To experiment with your self image in a different way than in a traditional portrait.

Materials needed: Camera with self-timer, tripod (if you have one), comfortable environment to take your photos, and any costume or props that you desire.

Instructions:

1. Find a space to set up your camera on a tripod, or, if you don't have a tripod, a fixed surface. Fix your camera in a location where you can put yourself in the photograph. Set your camera on self-timing mode.

2. Take a minimum of 20 photos of yourself without showing your face, leaving the camera in the same position on the tripod (you can take more than 20 photos if you like). Vary each photo. Be creative and playful, choosing any method you like of photographing yourself so long as you do not show your face.

3. Make a copy of the photos you have taken.

4. Write answers to the following questions:

 o What issues did you consider when photographing yourself?

 o Was it easy or difficult to represent yourself without looking at the camera?

 o Did you learn anything new about yourself through looking at the photos?

 o How did you feel in the process of taking these photos?

Additional instructions for groups:

Time frame: 60 minutes

1. Bring your photos to the group. Lay the photos in no particular order on a table for the others to see. Allow the others as a group to

organize your photos in an order that they think makes some sort of sense, as though the images told a story. **(30 minutes)**

2. As a group, decide upon a narrative that describes the images as they have been ordered. **(30 minutes)**

Questions to consider:

- Was the narrative that the group invented for your photos one that you might have chosen?

- Were you pleased with the order of the images the group chose?

- What criterion might you have set forth in choosing a particular order for the images?

▶ **Example: The piano player**

What issues did you consider when photographing yourself?
When choosing the setup for the shoot I was mainly concerned with representing things that are important to me. Hence the piano—I love making music—and the green cloth—green is my favorite color. When I started taking the pictures I was trying to somehow show my personality through my poses—dancing, playing the piano. Then, when I got more into it, I just started playing with new possibilities of hiding my face and exploring different ways of physically expressing myself.

Was it easy or difficult to represent yourself without looking at the camera?
At first it was a little tricky—it took me some thinking about how exactly I was going to represent myself. Would I be in the pictures at all, would I just focus so that my head would be "cut off" in the picture, what requisites should I use? Once I decided that I would be using mainly my body and the environment in the music room to paint a picture of myself, while hiding my face from the camera, things became much easier.

Did you learn anything new from it?
I feel like the most important aspect of this exercise for me was going into that room and, after setting up the camera, taking shot after shot and having fun inventing new poses on the spot. Maybe I learned that I can be a much more spontaneous and laidback person if I don't contemplate too much before every decision.

Figure 8.1

How did you feel during it?
I had a lot of fun. As I said above, by deciding to not take the photos too seriously I made this exercise a very playful and enjoyable experience for me, reminiscent of other improvisational activities, like writing or music.

Exercise 2: Alter ego

Purpose: To think about exploring paths you have not taken; to imagine what it would be like to act out a role that you do not play in your life.

Materials needed: Camera with self-timer, tripod (or fixed surface), costume and props.

Instructions:

1. Choose a role that you do not play in your life. You can choose any role, so long as you feel you can clearly represent this role in a photograph.

2. Take a photograph of yourself as this other character. Costume yourself to appear clearly as this person. If appropriate, choose an environment for your photo that helps elucidate the role of this character.

3. Write a diary entry or letter as the character you have portrayed. Think carefully about what this character might write—the scenarios they might depict, the voice and style of writing they would use.

Additional instructions for groups:

Time frame: 60 minutes
Take turns showing your image (or images) to the group and reading your writings. Everyone asks one question of each presenter.

Questions to consider:

• Why did you choose this particular character to portray?

• Do you relate in any way to this character? What was it like to portray this character?

• Is this a character that you admire? Respect? Fear? Detest? Are you ambivalent about this character?

- What are the core values of the character you have portrayed?

- What is the most striking difference between yourself and the character you portrayed?

- What message would this character give to you right now?

Example 1: From the desk of Wonder Woman

Figure 8.2: Person dressed up as the comic book character Wonder Woman.

From the desk of Wonder Woman
Saturday, 1 February 2008
On turning 50.

Such a busy week! So many injustices. So many people in need. Thank goodness for the other members of the Justice League! I have been blessed with strong and supportive comrades. We accomplish so much more as a group than I could all alone.

I will always work hard to retain my physical powers, but even superheroes age. As the first woman in the Justice League, I have broken down barriers and have set an example for the next generation. Now, I find it is time to pass the torch of the Amazonian side of me—the physical powers—to the next generation, and focus on the Athenian side of me. I won't ever slow down in the fight for justice for the less powerful. But, I'll put more emphasis on using my wisdom to prevent crimes before they blow into huge problems, and less emphasis on physical contests. I—and my compatriots—will wield our power to influence lawmakers, heads of state, and industry titans to ensure that the disadvantaged are given a voice and the opportunities they deserve to lead decent and healthy lives. Manifesting our power into political power to fight for victims of oppression and injustice will be the toughest fight of our lives!

Why did you choose this particular character to portray?
In general, I have shied away from taking front-line roles. Growing up, I was very self-conscious, a trait shared with my mother and my siblings. Also, I was told outright that I was not good in athletics by my friends. I accepted that I wasn't good at sports and felt satisfied that I was a good student, so I didn't need to be good at sports, too. I had the role of the "brain" among my more athletic friends and they accepted me as the smart one. But, I'm not sure they would have accepted me if I could compete with them in sports and was notably more intelligent, too.

Wonder Woman has beauty, brains, and athleticism (not to mention super powers) and proudly uses all of her strengths. Furthermore, she uses her special powers to fight for truth and justice, and stands out as the first female superhero character in the Justice

League. She's an icon that conveys the message that it is possible for women to be strong, smart and beautiful.

Do you relate in any way to this character? What was it like to portray this character?

I consider myself a strong, intelligent woman. I have grown to understand my strengths and have more self-confidence in my abilities—both intellectual and physical—over time. I don't think I would have been able to dress up as Wonder Woman and be seen in public when I was in my teens or twenties.

I first dressed up as Wonder Woman for a Halloween party at work when I was about 35. A colleague was dressed as Batman and we were representing a new division at the company. That first time I didn't have a flashy Wonder Woman costume; I created my own costume by copying a Wonder Woman doll that one of our programmers had in his office. It was a much less flashy outfit, but I felt more self-conscious at that time than I did 15 years later when I wore the outfit pictured here at a Halloween party attended by many of the same people.

Is this a character that you admire? Respect? Fear? Detest? Are you ambivalent about this character?

I admire the character for her inner strength and dedication to fighting for justice for the less powerful. And, perhaps most of all, the feminist ideal she embodies. But, as a comic book superhero, she is so obviously over-the-top that it is hard to relate to her.

What are the core values of the character you have portrayed?

Fighting for truth and justice are the values for which Wonder Woman is known.

What is the most striking difference between yourself now and the character you portrayed?

Oh, I think the physical differences are the most striking. Wonder Woman is portrayed as a much younger, bigger-busted, more imposing woman than I am. Plus, there's the long dark hair. I have short light-brown hair.

What message would this character give to you right now?

Let your inner strength and boldness show through!

Example 2: Diary of a Mob boss

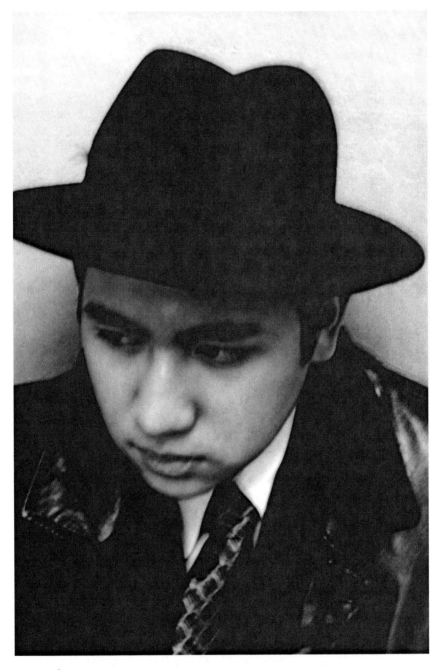

Figure 8.3: Person portraying his interpretation of a "mob boss".

"Intolerable!" I said these words as I looked into his pathetic begging eyes. I am his boss. I am the king! A lowlife criminal like him is in no position to beg forgiveness from me when he can't even perform that easy bank robbery I assigned him. These wretched and filthy creatures! All they know is to crouch down and beg for mercy. Mercy! I have none! Mercy! Mercy is for the weak-hearted.

They say that I am mean and cruel. I can feel the thrill whenever people are scared of me. That way, they don't come around asking things from me. And I am not burdened by listening to their emotional complaints and tearful stories of how they need my blessings and help.

"I have no more use for you," I said to him. He might have been one of my most used pawns but he is losing his usefulness. After he failed this bank robbery, he became nothing more than a disappointing existence to me. I am going to just let him go, let him run away from me. What will he do afterwards? I don't care! Care! I don't care about anyone. Care! Care is for the softhearted!

They say that I am cold and heartless. Who needs a heart in this world when you have power? Respect, fear and, of course, more power come through spite and cruelty, not through softness. From a powerful man like myself, don't expect warmth and compassion—I don't expect concern and sympathy. Such measly words just don't exist in my dictionary.

"It is strictly business, nothing personal," I added. Of everyone, he should know this the best. Having worked for me for over ten years, he should be aware his job is to just finish whatever task I assign him, and any failure of the task will not be tolerated. Don't anyone dare fail me. Failure! I won't stand failure of any sort.

They say that I am never content with my life. What's wrong with that? I have plans; plans to conquer the underworld. Until those plans are fulfilled, I am not going to be satisfied. And I am sure to be upset if these scrawny pawns mess up my plans.

Finally he left, downcast and dejected. I have to say knowing such a useless servant has left my command filled my day with ecstasy. After all, who wants to deal with worthless weaklings? My vision of a perfect world has no mercy, sympathy nor failure in it, just malice, callousness and finesse.

Why did you choose this particular character to portray?
My choice of alter ego is a mob boss because his personality is so different from mine. He is cruel, selfish and cold-hearted. There are times when I feel that I should hurt someone's feelings to get what I want, but my personality just will not allow me to do so. At those times, I wish I could be someone mean.

Do you relate in any way to this character? What was it like to portray this character?
No way! This character is a complete opposite to my own personality! When I was told about this exercise, it sounded like it would be a great experience to be someone else, even if for a short while. It turned out to be exciting yet at the same time instructive because I realized after the exercise that as much as I thought I would like to be cruel and nasty, ultimately I know it is not a pleasing personality.

Is this a character that you admire? Respect? Fear? Detest? Are you ambivalent about this character?
This is definitely not a character I would admire. I would probably detest such a person if I ever came across him.

What are the core values of the character you have portrayed?
He is selfish, arrogant and merciless.

What is the most striking difference between yourself and the character you portrayed?
Mindset. My alter ego has a mindset that centers around him. He will do anything he wants or needs to expand his power. Whatever actions he has to take to secure his power, he will not hesitate so long as it benefits him in the end. But for me, I love to help other people and I take pleasure in watching people improve as I help them.

What message would this character give to you right now?
To be satisfied with who or what I am. However strongly I wish to have as dark a personality as my alter ego, deep down I know that I will not enjoy a life like his.

Exercise 3: Unmasking the self

Purpose: To explore an aspect of who you are or would like to be that you don't typically show to others.

Materials needed: Mask forms, art materials (paints, crayons, markers, fabric, yarn, colored paper).

Instructions:

1. Purchase a blank mask form and some art supplies from a local art store.

2. Create a mask using whatever materials you wish, including paint, crayon, marker, cloth, paper, yarn, thread, etc. The mask could represent a particular role or part of yourself that you don't often get in touch with, or would like to play in the future. Be creative with your depictions of this role through your mask.

3. Once you have created your mask, take a photograph of it.

4. Ask yourself "what does this mask say about me?" Write a paragraph or two expressing your thoughts.

Additional instructions for groups:

Time frame: 60 minutes

Share your masks with the group by acting out the role or personality trait the mask symbolizes. Take turns asking questions of the person playing the role exemplified by the mask.

Questions to consider:

- What would others say about this mask? Would they be surprised? Scared? Pleased?

- What parts of yourself have you kept hidden and why?

- Can you see any value in displaying this hidden part of yourself to others?

▷ Example 1: Self-control mask

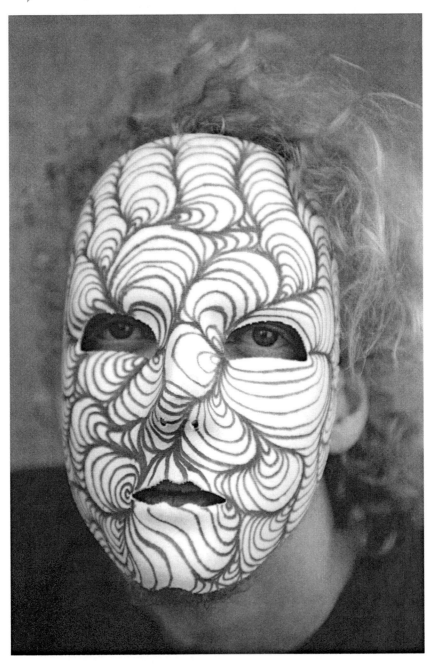

Figure 8.4

My mask represents neither a role I would like to play, nor any part of myself that I am not in touch with. Rather, it is an exploration of the ways in which I control my self. The design on the mask seems arbitrary and abstract, but it was constructed according to simple flexible rules. The repetitions of lines begin at certain points spontaneously, and end to prevent conflict with preexisting forms. The ways in which I allow myself to begin new structures in the drawing are limited. But within this structure, I have allowed the individual decisions to be made intuitively. This parallels my mental state closely. I have certain strongly held limitations I keep against my behavior, but within those bounds, I act intuitively, sustaining a closeness between my actions and my thoughts that I attempted to make evident through the patterns of my mask.

Example 2: Mature, sweet, mastermind mask

Figure 8.5

I drew the brain to show that I secretly aspire to be the mastermind of some projects, or be the "invisible hand" driving a campaign. I want more defined contours on my face, and want my face to look a little less childish so that people will take me more seriously at work. I extended my lips because I want to always look sweet and happy, which cheers other people up as well.

Bringing it all together

The examples above show how diverse and complex our alter egos can be. Altruistic superheroes, evil mob bosses, and masks that display hidden facets of ourselves illustrate only a small range of the possibilities we might explore. Some of the attraction to playing these various roles is that they are so different from the way we generally present ourselves. The very idea behind many superheroes is that they lead double lives: Clark Kent versus Superman, Bruce Wayne versus Batman. These characters change their physical appearance from superheroes to their mainstream selves in order to protect their anonymity. The person who chose to depict a mob boss states clearly that he does not want to be a mob boss in real life, nor does he respect or envy the mob boss's existence. Yet trying on this role permits the writer to explore more assertive behavior, to play with elements of the mob boss personality, and to get in touch with pieces of his own shadow self.

How can you continue to explore different sides of yourself in your daily life? Here are a few suggestions:

- Add to your journal, writing in different voices. For example, one day you might take on the role of a worrier—the next day you are an optimist. Or you could have a dialogue between worrier and optimist, exploring an issue from different views.

- Dress up occasionally in costume. The costume doesn't have to be fancy. Sometimes just a hat will do. Allow yourself to take on a new role, if just for a moment.

- Act in a play; it is an excellent way of trying on new roles that might have implications for you in your personal life.

- Keep a few blank masks on hand and some art supplies as a way to explore alter egos with friends. Imagine having a mask party where everyone makes a mask of the worst or best parts of themselves, or the part they would most like to be.

- Put together a collage of your own masks reflecting different moods. This allows you to be artistic and monitor your moods at the same time.

Although these exercises might seem strange or unfamiliar, keep in mind that exploring new sides of yourself can be fun and invigorating and can help you grow.

CHAPTER

Self in the Future

Overview

Maturity is marked in large part by our ability to take an active role in planning our future. It is difficult to set out a course of action if we don't have a goal in sight, or if we fail to accept the reality that choosing one path means foregoing others that would lead us in different directions. Of course, even if we stay on the chosen path, we might not end up where we thought we would due to unforeseen obstacles, opportunities, and circumstances. The future is uncertain, even if we have a very clear idea of where we think we want to end up.

And, of course, life as we know it is finite. Thinking of our lives as inherently limited affects how we perceive our futures and how we plan for those futures. It is helpful to view those limitations in a constructive way, as a way of improving our present, rather than fearing our future or ignoring it. As you visualize yourself in the future, what images come to mind? How do you think your life will play out? What goals, if any, are you setting for yourself now that will guide you towards that future? These are questions which you may or may not have asked of yourself up to this point, but which are important to consider when conducting your life in a way which is mindful and purposeful.

There are many different approaches to imagining our futures. Some of us approach the idea of a future life in a more intuitive way, preferring to respond to circumstances as they arise, as opposed to plotting a more premeditated course. Others are planners by nature,

mapping out future circumstances in detail. Neither approach is intrinsically good or bad. We may find, however, that one or another approach serves us better depending on the kind of issues we are considering. Look back on some of the choices you have made in the past. On what basis did you make those choices? Were they guided by faith, data, or your gut feeling? Have those choices worked out as you predicted? If not, how did you react to the unexpected outcomes? If you were to do it all over again, would you make a different choice? Now think of a decision you have made in the past that you view in some way as a "bad" choice. Ask yourself why this was a bad choice. What did it teach you? Did you learn anything that could help you make a better choice in the future?

How we see our futures depends partly on how old we are and where we believe ourselves to be in our own timelines. A person who expects to live for another 60 years will probably think about his or her future differently from someone who expects to live another 20. An older person will have a lifetime of experience making choices, and will tend to draw on this experience when making future decisions. Younger people, on the other hand, may depend more upon the advice and influence of others who have already been through many life experiences.

Becoming your own person means questioning the messages you get from others about how your future should develop. This is especially true for young adults in the process of separating from their parents and figuring out who they really are as independent individuals. Often, young adults want to make decisions for their futures based on their own experiences, personal beliefs, and dreams. For some, it may seem like a luxury to have the opportunity to ponder a future over which they feel they have control. Still others may consider the choices overwhelming, and opt to defer to the wishes of family or society. In either case, families often exercise great power over how adolescents and young adults plan their futures, and conflicts can arise based on the disparity between the family's view of their futures and their own.

When contemplating your future, it may be valuable to consider options that you never have considered before, to entertain the possibility of change, and to recognize the power of visualization. The exercises that follow are designed in the spirit of exploring the possibilities, not as definitive blueprints. As you create a record today of your

thoughts and feelings, you will have better tools for reassessing your objectives in the future and seeing how they may have changed. Although you may not end up accomplishing all that you like—or may end up in a very different place than you imagined—it is useful to take time to think ahead and dream. Setting a course of action is important in leading a healthy life, but so is the ability to take advantage of "twists of fate" that may alter that path. Have goals, imagine a future and plan accordingly, and then be receptive to changes as they arise.

Exercise 1: The future is now—a comic strip

Purpose: To project yourself into the near future, and to play out a particular scenario by creating a comic strip that explores the scenario and its outcome.

Materials needed: Paper, pencil, colored pencils, crayons.

Instructions:

1. Choose a specific scenario concerning an upcoming event directly involving you in the near future (sometime during the next week). Pick an event for which the outcome is uncertain.

2. Design a strip that explores this scenario and projects an outcome. You should use as few frames as necessary to effectively explain your story (no more than ten frames). You can use simple stick figures and line drawings to portray your characters and scenario. Be sure that your stick figures are identifiable from frame to frame. You can use different colors to distinguish your figures or give them name tags. Write any dialogue or supporting commentary below your frames, or use balloons.

3. Examine your comic strip after the event it depicts has taken place. Write a short paragraph that addresses the following questions:

 o Why did you choose this particular scenario to depict in your comic strip?

 o Did you correctly predict the outcome of your real-life scenario in your comic strip?

 o Was it helpful in managing the real scenario to create this tangible manifestation ahead of time?

Additional instructions for groups:

Time frame: 30 minutes

1. Complete all the steps in the above exercise instructions for individuals.

2. Make enough copies of your strip to give a copy to every member of the group.

3. Take turns explaining your strip to the group. **(30 minutes)**

Questions to consider:

- Can you imagine making such a comic strip for an event farther away in your future (a year, 5 years, 10 years, 20 years)?

- If done in a group, what did you learn from reading other people's comic strips? Were there any similarities between the scenarios depicted in the various strips?

▶ **Example 1: The encounter**

Figure 9.1

I chose this scenario because it depicts a situation that had become increasingly difficult for me. I had repressed for several years information I thought my boss needed to be told about others in the office. Because I wasn't sure how he would react, I was worried that I possibly could be fired as a result of confronting him. Fortunately, when I was summoned to his office I was not fired; rather I

was treated with respect. Although he did not want to discuss the past in detail, he did agree that we could turn a new page in our relationship and handle matters that pertained to my job one-on-one without involving others in the office. I believe that imagining this scenario in the form of the comic strip may have helped me prepare for the confrontation which turned out well for me.

▶ **Example 2: My first fencing bout**

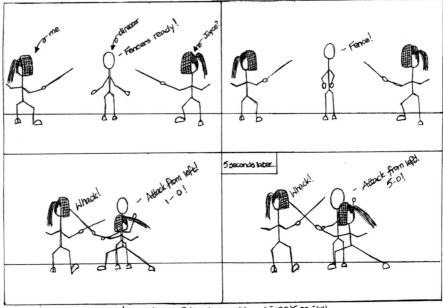

Figure 9.2

Why did you choose this particular scenario to depict in your comic strip?
It was an upcoming event that I was somewhat uncertain about.

Did you correctly predict the outcome of your real-life scenario in your comic strip?
No, my first bout was against someone else, and I actually managed to land a few points before he beat me.

Was it helpful in managing the real scenario to create this tangible manifestation ahead of time?

I wasn't really anxious about it, and thought that the likely ending (the one I drew) was pretty amusing.

Exercise 2: Fork in the road: Where do I want to go from here?

Purpose: To create two different self-portraits depicting yourself as you imagine yourself to be in the future; to help you consider the consequences of different courses of action.

Materials needed: Camera, props to identify your environment, appropriate costumes (based on your choices), and (if applicable) others to help depict your future scenarios (i.e. someone to portray a spouse, child, boss, etc.).

Instructions:

1. Picture yourself at a fork in the road 15 years from now. This fork depicts two different choices about an important topic. The topic can be about anything—a job, a relationship, whatever you like. Assign a different outcome for each fork.

2. Create two distinct photographic self-portraits, one for each choice, depicting the things described in the questions above. Be creative and attentive to detail. You can photograph yourself with an imaginary family or a relationship. You can ask your friends to help you with this.

3. Answer the following questions about each of the two outcomes:

 o What am I doing professionally?

 o What are my significant relationships (family, friends, colleagues)?

 o What does my environment look like (home, work, play)?

 o Why did I choose this path?

 o How do I feel about this choice?

Additional instructions for groups:

Time frame: 60 minutes

1. Complete all the steps in the above exercise instructions for individuals and bring your self-portraits and writing to the group.

2. Share your two self-portraits and your thoughts about the different directions you took.

Questions to consider:

- Which of the two choices that you portrayed do you prefer?

- What process did you use to weigh your choices?

- What are the positive aspects depicted in your portraits? Drawbacks?

- How realistic do you think your projections into the future will be?

▶ Example: Different paths

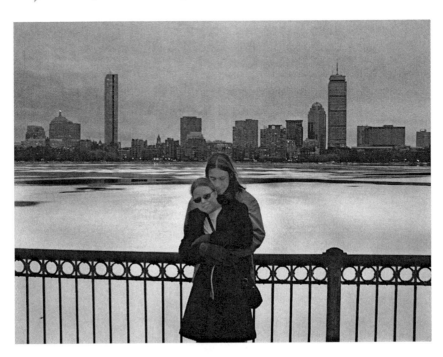

Figure 9.3: Drew's fork (A).

Professionally, I am a high-level technician (someone who oversees projects, etc.) in a major cybernetics corporation. I spend my days working with and overseeing the others in lab, where I create brain-machine interface technology and other devices that use it.

My significant relationships include friendships with my colleagues in the company, as well as with people I know from hobbies (such as a couple of sci-fi buffs, etc., that may not work at my company). Most of them are probably college friends who have stayed in the area. I have a husband who also works in a scientific field of some kind, but he and I have no children. My parents are still alive, although they're aging, and I fly to see them as much as possible, and sometimes they fly up to visit and stay in our house. My sister is now about 50, her husband somewhat older, and they do most of the caretaking of my parents due to being closer to them. Their children are grown and working; I see them sometimes as well. My grandmother is (still) living, though now she'll be reaching her 100th year and probably has little time left. She's a healthy woman and always has been, so I expect she'll live a bit longer.

My home environment is a comfortable two- or three-bedroom house; we have room for guests, but we don't need an enormous amount of space. I live in Boston, though not in the inner city (no room for a house there), so I commute via public transportation to work. At work, I am in a high-tech laboratory with the newest equipment and a close group of colleagues that are dedicated to their work. For fun, I'll collect some nerdy friends and play video games, or chat about books, or go out to dinner, or maybe go to the beach in Boston and just have some old-fashioned fun in the sand and water. We go exploring in places like the arboretum and sometimes rent a car and drive out to the country if we feel the need to get away.

I chose this path because it means I can have the career of my dreams while not stretching friendships to the limit by moving a great distance. I still get to live on the East Coast, near the water, and I'm never bored with the city nearby. I'm in the middle of technological advancement and have a strong hand in its development. The city is also conducive to the eclectic, hair-dying, fire-spinning, wild culture I like. It's cold up in the city here, and I love winters.

I feel that this choice could be one of many things: it could be a cop-out (not wanting to brave the great beyond by leaving friends and a well-known location behind), a forsaking of part of my life (by not having so much time for my art and writing and leaving the laidback country lifestyle I knew so well), or it could be a move into the future (by throwing myself into the progress of technology and enjoying the fruits of my labor and watching my inventions spread). Unfortunately, I'm a little intimidated by this choice, because the city is so busy that it can sweep away your time before you have a moment to think about what you should be doing, and because the culture in urban areas tends to be less religious (unlike myself, who is very Christian). It also means I don't get the nature environment I'd like. I've never enjoyed the cityscape.

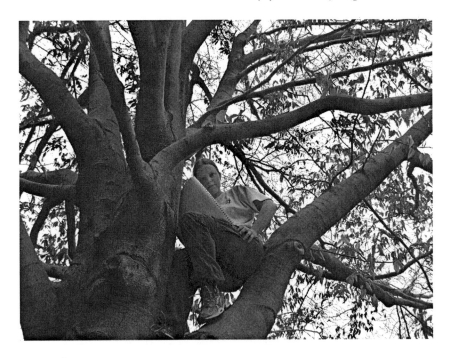

Figure 9.4: Drew's fork (B).

I'm working in a smaller-scale company, probably on something related to cybernetics but not as involved as where I'd be if I were in a big city. It's probably in a "subtown" of sorts, a distant suburb

of a bigger, more southern city that has become its own town (rather like Marietta is to Atlanta or Long Island is to New York City). I have loose hours because the people there are relaxed and not having to manage several hundred workers at once. Everyone knows me personally, and I oversee a project or two.

I have no husband or children; replacing them is a group of friends from around the area, some of whom are nature types, some of whom are artsy or writer-types, and some of whom are my colleagues. My family lives closer to me and we see each other almost weekly; my sister's family is at a similar distance. I sometimes see my college friends, but they have to travel far to come visit me, because most of them live in the cities up north. I help take care of my family and my aging (almost 100 now) grandmother whom I see often due to her age and proximity to death.

My two-story home is in a wooded area a few minutes outside the city; it's large enough to hold a group of friends or just have a party one-on-one with a friend and some food and a good movie. I own a blue convertible (like I used to when I was in high school) and drive to work every day. Wherever I live, I'm on the East Coast in a place where we have all four seasons in force (warm summer, cold winter, colorful fall, vibrant spring). At work, I'm in a sprawling complex that doesn't involve a lot of glassy towers and stairs, and I work in a technical but not overwhelming environment. When I'm having fun, my friends and I swim in my pool, go out to the beach (or lakefront, whichever is closer) and lounge around and swim, ride horses (I'm sure a neighbor has them somewhere), or just stroll through the woods and climb trees and talk for hours on end.

I chose this path because I love nature and don't want to give up the slow life I learned back in the South at home. I'm trying to reconcile my dreams with my old desires (to stay in the Southern atmosphere forever). People are more friendly in the country; there's more time for hobbies and play; the environment is more interesting and not full of reminders of urban nature-corruption. One doesn't see smog and can view the stars at night. The world is more black-and-white; people seem to be heavier on tradition and less on American-style, "Whatever works for you," culture. I also love having real Earth around me, not all the fake cityscape

atmosphere like glass buildings, huge skyscrapers, and ubiquitous crowding of buildings.

I feel that this choice is probably the lesser of the two, if only because it removes some of the opportunities I'd have if I were in the city. I can give up my old lifestyle and probably should if I want to follow the progress of technology and really live my dreams. The people in areas like this don't support the eccentric culture I like; they're less understanding of "kids these days" (oddly, 35 is young to many people), and I won't be able to find as many good friends due to the lack of population in smaller towns and the tendency towards an older-style culture. There is less variety in the residents. I'm not sure if I'd be socially happy here, or if I'd ever find a mate in a place like this. It's also too hot in the South.

Exercise 3: How do I want to be remembered?

Purpose: To consider the things you want to accomplish during the course of your life, and to think about how these things will be perceived by others.

Materials needed: A sampling of newspapers with an obituary section; paper and pen or computer.

Instructions:

1. Look through several obituaries from a range of newspapers. Use some local news sources, as well as a national-circulation paper such as the *New York Times* or *The Christian Science Monitor*. Look at the way the obituaries are written, taking notice of their form and the common themes that recur from one person to the next.

2. Write your own obituary as though you had lived a long, full life. Do not put down a specific date or cause of your death. Use the other obits that you have read as a model for your own. Give your obituary a sense of realism, so that someone else reading it would find it plausible. However, let your obit reflect your life the way you would like it to be. This is your final biography, so think carefully about the highlights of what you'd like to have accomplished before you die, and put it down on paper.

Additional instructions for groups:

Time frame: 75 minutes

1. Bring in the obituary you have written.

2. Take turns reading the obituaries out loud. **(60 minutes)**

3. After each obituary is read, you can field questions from others about what you have written. **(10 minutes)**

4. Discuss if people found this to be an easy or difficult exercise and why. **(5 minutes)**

Questions to consider:

- When reading obituaries in the newspaper, what did you find most interesting about them? What can you tell about the character of the people from their obits?

- What was the single most important idea that you wrote about in your own obituary?

- Of all the things you wrote about in your obituary, which things seemed hardest to predict? Which things seemed easiest?

▶ **Example 1: Obituary for Charlton A. Moses (written by a 20-year-old)**

Dr. Charlton A. Moses, the lead investigator in the hunt to pin down the neural basis of consciousness, died Saturday at Stanford Medical Center in California. He was 96 and lived in California. Dr. Moses devoted his life to improving those of his patients, many elderly, as a neurosurgeon. When he was outside of the operating room, he enjoyed traveling, writing and spending time with his family.

The first in his family to achieve college and post-bachelor degrees, Dr. Moses graduated with a degree in Brain and Cognitive Sciences from the Massachusetts Institute of Technology, and went on to Stanford to earn both an M.D. (with a specialization in Neurosurgery) and Ph.D. in Neuroscience. His investigations led him to uncover the complex mechanics beneath human skulls that orchestrate internal experience. He sought answers for age-old mind-brain, body-soul questions that intrigued philosophers and scientists alike since the time of the Greeks. In addition to his research and clinical work, he also sat on numerous local and

national boards. After retiring, Dr. Moses spent more time writing and reading, and continued his clinical life by diagnosing patients. Throughout his life, he produced 383 peer-reviewed articles, and wrote four novels and a collection of short stories.

Dr. Moses was inspired by the writings of Whitman, Woolf, and Proust, and the style of Dostoevsky and Hofstadter. In his journals, he noted that "these were brilliant authors who wrote analogies to educate the reader on issues of science and society." He felt they "pushed the envelope, and in true form their art anticipated the discoveries of modern science." Dr. Moses wrote about the brain and its relation to consciousness and the soul. With his pragmatic belief that the value of knowledge was in its use, he wrote both for the education of the layperson and also pressed scientists to consider a broader approach to the brain. His most famous collection of short stories included "Dialogue of the 18 Minds," in which he discussed what it might be like to clinically lose what we refer to as our sense of self.

Dr. Moses is survived by his wife, their son and daughter, his younger brother, and five grandchildren.

What was the single most important item that you wrote about in your own obituary?
The most important item I noted in my obituary was that I will make some discovery and share my knowledge with the masses through writing. If I could choose a parallel item of importance to me, it would be that I enjoyed family life.

Was this a difficult exercise, or did you find it easy? Why?
This was an extremely difficult exercise. It's forced me to consider specific achievements and direction beyond the immediate, and focus more on the highlights of my future career. I know generally what to expect in the next five, even ten years, and see lifelong interests and hobbies taking root. Yet I am somewhat at a loss to discuss the complex molding of events and specific dates that form a cohesive life.

Of all the things you wrote about in your obituary, which things seemed hardest to predict? Which things seemed easiest?
As a student, I am continually planning the next step to success. It was easiest to begin with where I died, how I began, and my

primary career highlights. It's easy to say that everything else proved difficult to engender, especially providing specific events and achievements that helped shape who I was before my passing.

▶ **Example 2: Obituary for Tessa Murray (written by a 43-year-old)**

Tessa was born in Newport, Illinois to Susan and Richard Thompson on 30 December, 1965. At 22, she relocated to New Jersey where she met and married her husband, John Murray, in 1989. In 1990, they moved to Oswego Lake, New York and lived there until her passing.

A 1984 graduate of Newport High School, "Home of the Newport Pretzels," Tessa was very involved in swimming, running, and singing while in high school and she credits these experiences in developing her courageous spirit. One of Tessa's more interesting experiences was her reign as Miss Newport 1985 and participation in the Miss Illinois Pageant. Although her feet took her to the East Coast, her heart remained in Newport and she always considered herself a "Midwest Girl."

Over the years, Tessa spent a total of ten years in the graphic arts industry as a customer service representative and sales executive in addition to various other job experiences. In her thirties, Tessa decided that a formal education would give her greater opportunities and accumulated a Bachelor's Degree in Mathematics, a Master's Degree in Organizational Behavior, and a Master's in Clinical Mental Health Counseling throughout the years.

Following her stint in Corporate America, she decided to consolidate her work and educational experiences into a position of leadership for the *Women for Women* organization. Tessa was integral at raising funding and increasing awareness across the entire United States, and then globally, about the life-changing work that *Women for Women* does for societies such as the Congo, Serbia, Rwanda, and Uganda.

While at *Women for Women*, Tessa developed an educational program used for training mothers in raising their sons to become non-violent, socially responsible adult men. Her program was instrumental at ultimately ending the civil war in the Republic of the Congo after five years of its implementation. Her book, *Raising*

the Sons of the Congo, sold over a million copies and has been utilized as a blueprint for improving the lives of the citizens within several countries experiencing civil wars. Tessa was honored with the International Humanitarian Award of Achievement in 2035.

In 2033, Tessa and John retired to Tuscany where they lived before John's passing. Tessa and John celebrated many years of friendship and marriage and in the latter part of their relationship they traveled extensively and enjoyed their homes in Oswego Lake and Tuscany. Their many activities expanded from camping, motorcycling, and traveling to see family and friends across the globe. Their favorite activity was simply sharing time together while holding hands.

Tessa, at 89, was surrounded by close friends and family at her bedside at her final bidding. Together they all laughed, reflected on their friendships, and shared their hopes and dreams for one another. Tessa's parting words were, "Thank you for your influence on my life. You've challenged me to grow; you've comforted me; you've lifted me up. You've rejoiced with me; you've cried; and here you are today, enveloping me in love and peace. Thank you. I am truly blessed."

In lieu of flowers, donations can be made to either womenforwomen.org or Central Asia Institute (ikat.org).

I have posted a copy of my obituary at my desk so that I can be reminded every so often of how I am, or am not, aligning myself with it. What a fun and informal way of preparing a 5-year, 10-year, and 20-year plan! The timeliness of this exercise really helped in giving my life a new direction. What an overwhelming sense of gratitude I have for the past, the present, and the future. I'm looking forward to having my partner put together his own obituary.

Bringing it all together

Visualizing ourselves in the future is an exercise in projecting into uncertainty. At times this may seem like a simple task, especially if we are used to following a familiar routine. Certain stages of our lives may have more clearly defined structures. In our school years, for example, there is a clearly defined progression through a curriculum and well defined expectations. At other moments, looking into the future may seem a bit

daunting. For many of us, it is the fear of not knowing that can make the idea of voyaging into the future an uneasy experience.

Thinking positively about the future takes practice. In order to get comfortable with the unknown, we need to revisit the idea of our future with some regularity. If we become too complacent with our present, it is easy to become myopic, to see only what is directly in front of us. By periodically taking stock of our future, we can gain greater perspective about that future and become more mindful of our present. Consider building in some time to reflect on your future and the choices you are making now to create that future. One way is to keep track of your choices in a journal, stating why you made that choice and what you hope will happen. You may want to keep copies of your responses to the exercises in this chapter and date them. You can then revisit these same exercises in a year, five years, or ten years and see how your responses might change over time. Another way to help yourself make important decisions is by creating a decision grid, where you rate the factors going into that decision, and look at the interplay between those factors.

Sometimes, when faced with a decision, we don't know how to trust our gut feelings. Taking time out to write about it can help. Actually placing ourselves into a future scenario in a tangible way can be useful. For example, if we are thinking about starting up a business, we can make up sample business cards or create a sample brochure with our photograph on it. Talking to others about our possible choices can be helpful: hearing their views can stimulate us into seeing different sides of the picture we might not have seen before, or encourage us to take risks we might otherwise be reluctant to take.

By definition, the future is always before us. It is what we do in the present to help shape that future that counts. Being mindful of what we want for ourselves, what our hopes and dreams are, and what we need to do to achieve them is a crucial part of being a whole person. Even though the future can hold surprises and our dreams can fail us, our ability to plan ahead can bring us a sense of purpose and meaning.

CHAPTER 10

Creating a Mixed-Media Portrayal of Self

Overview

If you have done the exercises from the previous chapters, you have already generated a variety of materials that record your thoughts and feelings about your values, beliefs, and experiences. We now encourage you to go beyond the exercises and create something even more personal, taking the ideas put forth in the exercises to another level. We will discuss ways that you can create a project of your own design, focusing on a topic or topics of your own choosing. This self-portrayal should have a single, clear purpose: to express something close to your heart using any variety of media that suits you. If you are comfortable with writing, use writing as your primary tool. If you are more at ease with images, concentrate your energies on telling a story through pictures. Whatever your choices, they should be personal to you and your way of seeing the world.

Why create a self-portrayal in the first place? It gives you an outlet and a focal point for expressing yourself in a creative way. It also affords you the opportunity to express your ideas to others. If you do choose to present your portrayal to others, there is an added possibility of getting feedback. This feedback—the reflecting back of your ideas from someone else's viewpoint—adds a new dimension to the process of self-exploration. But the most important part of creating a self-portrayal is the process itself, from the choice of materials and subject matter through the design and execution of the project. This process

160

underscores the relationship between self-exploration and self-expression as discussed in Chapter 2—the inextricable link between how we express ourselves and how we come to learn about ourselves.

Who will be the audience for your self-portrayal? This is entirely up to you. No one else need see it but you. Then again, you might think of this as a way of expressing your ideas to someone else. Perhaps you want to create something as a legacy for your children or grandchildren; maybe this is something to make and give to a close friend or loved one; you may even want your work to be seen by strangers, as a way of educating them about you and your world.

Beginning your self-portrayal

Coming up with a concept for your self-portrayal is a very different process than doing an exercise. The structure of your portrayal is for you to design; it is not something we can supply for you. Allow yourself some time just to entertain different ideas and to consider an approach to this project that suits you best. As a starting point, review the materials you have already created through the exercises. What are the themes you found most compelling? Which exercises were most pleasurable for you to do? Which ideas were most revelatory? Try to identify which concepts affected you most, noting which components of the exercises you enjoyed most. Did you create or collect photographs? Was there a writing piece involved? Did you draw or paint something that particularly pleased you?

Your portrayal is a cohesive narrative about you and should present an idea or set of ideas in a clear and articulate way. As you begin looking through your materials, think about what you would like to say with your self-portrayal. You might decide to focus on a particular event or time period in your life, or you could choose an autobiographical approach, touching on key moments in your life over a period of time. You might choose a single theme or idea that depicts a feeling or particular point of view. You may decide right away that there is a clear theme that you want to express. Alternatively, you may favor a particular medium or combination of media and generate a theme from there.

There is no right or wrong way to approach this process. You may want simply to free associate on paper, writing down ideas as they come to you. To help you brainstorm what form your self-portrayal can take, look for inspiration outside your immediate surroundings. There are many models that illustrate ideas on how to bring materials together in different and creative ways. If there is a museum or art gallery near you, consider making a visit to see how artists use different ways of combining materials. The Web is a boundless source of artists' images. Try doing a Web search for images using any of the following keyword phrases: *art collage, mixed media, narrative art, memorabilia art, art and text, art from found materials, art of the self, artists exploring self, visual interpretations of self, self-portraiture.* Make a note about which works resonate with you and why. Are you drawn to the particular message? Do you like the visual quality of it? Does it combine media in a way you find particularly gripping? What elements of the artist's work might you like to emulate in your own work?

Your self-portrayal comes from you and, ultimately, is for you. It should be something that you enjoy doing. Try to choose subject matter that you find compelling, something close to your heart, something personal. If you have many ideas and materials, you may decide to do a series of smaller self-portrayals that explore a variety of ideas or that use multiple media. You could think about creating a single portrayal that can be added to and expanded over time. However you choose to think about your self-portrayal, regard it as a slice of your life, not a comprehensive accounting of who you are. As there is no single correct way to think about this project, allow yourself to explore freely. The goal is to think creatively about how to express your ideas, while engaging in the spirit of play throughout the process.

Designing your self-portrayal

After working through your ideas on what to portray, gather together your materials if they pre-exist, or create the components that you will need. Find a workspace where you can spread out. Once you have collected your materials, start to visualize the finished work in your mind. You may want to sketch it out, or perhaps construct a small model if your piece is multi-dimensional. See how the materials work together in

ways that help illustrate your narrative. Take note of elements missing that would help express your ideas. Does your piece need a written component to explain some of the visual elements? Conversely, would adding a visual element help illustrate the writing?

Keeping it simple can often be the best approach when designing a project. We don't want to discourage you from experimenting with new materials or novel ways of organizing your ideas. On the contrary, we want you to let your imagination run freely and to synthesize your ideas using media in ways that will effectively illustrate your thoughts. With that in mind, be aware of your limits. Having an idea that is too ambitious may lead to frustration, especially if there is too much time or expense involved. Your portrayal should be a project that is both attainable and pleasurable. Consider how much time you have to work on your portrayal and give yourself a target date for completion. If you want to work on this project a little at a time for several months, be sure that you can carve out time to work on your project regularly. If too much time elapses between working sessions, you can lose the thread of your ideas. Think about using materials that are within your budget. If you rely on found or collected materials for your portrayal, you are unlikely to run up expenses.

The design of your project is itself a form of creative self-expression. As you start to think of its physical manifestation, consider how the design will help to support your subject matter. There are a number of ways that you can do this. If your idea is to portray a particular event or era of your life, you may want to represent your narrative in chronological order. In that case, whatever mode of design you choose should lead the viewer from one event to the next as a way of helping him or her understand a logical progression of time. Or perhaps your idea will be to address a particular recurring theme or idea that does not need to be recounted chronologically. You will then have more flexibility with your design, as it does not need to outline your thoughts in a linear fashion. Yet another consideration is modularity. Will you want to add to your project over time? Your life will change, and you might well benefit from having a project design that permits you to add components over time, whether it is written or visual material.

Think about using any and all elements of your portrayal to help express your ideas. What significance might colors have in helping you

to express yourself? If you are using written elements, how does your choice of font (if printed) or writing implement help to illustrate your portrayal? How is it different writing in crayon versus pen or pencil? If you are using photographs, is it possible that making them in black and white or monochrome will have a stronger impact than in color? If using other elements in your portrayal, does size or placement help you to create a hierarchy of importance in your design? Think about each element of your portrayal and ask yourself how you can arrange these elements in a manner that will best illustrate your point of view.

Finally, consider where you will put your self-portrayal once it is completed. Is it something that can easily be protected and stored? How? Will it hang on a wall? Will it be easily accessible to examine or add to at a later date?

Exercise: Organizing your thoughts

Purpose: To organize your thoughts about your self-portrayal; to gather your ideas together in order to clarify the content and design of your project.

Materials needed: Pen and paper or computer.

Instructions: Answer the following questions:

1. On what area of your life will your project focus? (i.e. a specific aspect; the past, present, or future; an abstract concept, idea, or feeling)

2. What elements will you use in your project? Writing? Photography? Art? Memorabilia? Found materials?

3. What role will each of these elements play in depicting your story?

4. How will you organize your project? (i.e. chronologically, by turning points, around a single main event or idea, or by important relationships)

5. What mode do you want to use to represent yourself? In a factual way? In a fictionalized way? In the third person? Through other people's eyes?

6. What materials do you already have that you will use in your portrayal? What materials do you need to generate yourself?

7. Where will your portrayal finally reside? What issues do you need to consider for storing, maintaining, and displaying your project?

Self-portrayal in a group context

As is the case with all the exercises in this book, working on your self-portrayal in a group context can bring an added dimension. Creating a self-portrayal that others will see allows you to test how well you communicate your intentions. It gives you an audience for your ideas and provides an opportunity for everyone to learn through observation and discussion. It can also help others to better understand you—and in turn better understand themselves. Feedback from others can take place throughout the process, offering peer review that can be helpful as you fine-tune your project.

Once you have finished your portrayal, consider discussing the following questions with others in a group:

- How do the physical construction, presentation, and organization of your portrayal reflect on the content?
- Why did you include what you did?
- What does this portrayal mean to you?
- If you were to display this self-portrayal in an exhibition, how would you title your portrayal?
- From your self-portrayal, what would you most want someone to know about you?

Since your portrayal will likely contain a variety of media, it is essentially a visual entity with written elements. If working with a group of people, you may want to consider creating an exhibition of your self-portrayals. An exhibition serves several purposes. First, it is a way of honoring the work by giving it a specific, exclusive place to be displayed. Second, it offers the opportunity for others to see your work and to share in your experience. Third, it provides a forum for feedback and discussion.

Examples of self-portrayals

▶ **Example 1: wa*lt*er**
Materials used: Photos, poster board, tracing paper, pens, pencils.

Figure 10.1: This work is approximately 24 x 30 inches in size, and combines writing, photography, and drawing.

Figure 10.2: This figure illustrates one detailed panel from the "Sudoku".

Artist commentary:

My whole project consists of the struggle of various media trying to take over each position on the Sudoku board. This struggle physically represents the inner struggle of my thought process and methodology for the decisions that I make. This struggle is represented by the conflicting media in terms of color versus grayscale, photos versus drawings, and opposing handwriting styles. Each style represents a particular aspect of my decision-making protocol (i.e. grayscale=family, drawings=alter ego, etc.). The Sudoku board represents the map in which my decisions dictate

where I go, since there are many different possibilities and different situations to take into account. But the fact that there is usually only one solution per board implies that, regardless of which factors went into making the decision of a particular box (whether it be dominated more by one medium versus another), that box is filled by a particular answer.

This project gave me an opportunity to actually physically represent this inner struggle that I've never really put much thought into. I've always been just "me," but never really considered how or why I make these decisions about my life. To really be able to artistically represent this allows me to delve deeper into my mentality to get a full understanding of my inner workings. It lets me explore the abstraction more in depth, and could also perhaps explain this mentality to others who do not understand.

I have learned that I take a lot of decision-making processes for granted. Sometimes I make decisions without really thinking about why I'm making that decision, other than it's what I feel is right. To get to take a look at the nuts and bolts gives me great insight into myself and how I function.

▶ Example 2: Dressdown

Materials used: Hanging mobile constructed from photographs, index cards, ballpoint pen, silver jewelry wire, plastic, glass, multi-colored wooden beads, wire coat hanger.

Artist commentary:

I do not "buy" clothing in the conventional sense. Rather, I collect it. The articles in my closet are much more than a means of cover-up and instead represent a stage in my development, a significant event, a place that has meaning to me, or a person that is close to me. Collectively and without any additional input, my clothing's stories could give an accurate description of my values, my relationships with others, where I've been, and where I might be going.

The aim of this work was to analyze the relationship I have with my clothes by decomposing my wardrobe into individual elements and using these to construct an image of myself. When selecting articles of clothing to be photographed, I tried hard to select only clothing I would wear on an average day to walk

Figure 10.3: This mixed-media piece is constructed using photographs, thin-gauge wire, beads, and a coat hanger. The work hangs approximately 5 feet tall.

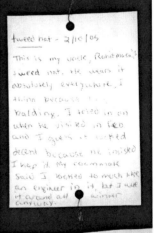

*Figure 10.4: The panels above show details from "Dressdown."
The bottom two panels show the back sides, revealing stories
written about each article of clothing.*

outside of my room. Therefore, something like a team uniform, dance shoes, or a traditional Indian outfit is not included. I didn't want the project to show me through different roles I play. Instead, I hope to reveal everything I carry with me on the inside using my outside appearance.

When you look at my work, be sure to observe both sides of the project and their relationship. Some things to think about:

- My clothing seems to tell more stories about females than males. Is this always true of clothing, or is my project unique in this respect?

- Are some articles of clothing (i.e. jeans vs. a necklace) innately more capable of conveying a story than others?

- What stories do your clothes tell about you and your world?

The examples above show creative approaches to self-expression and explore themes that are relevant to the creators and their peers. These portrayals were presented in exhibition in a college gallery and were viewed by the college community as well as the general public. The response to this exhibition was powerful, in large part because the audience were able to share their impressions with the creators of the work through comment cards as well as in person during a public reception. The creators of the portrayals reported that the experience of presenting in an exhibition added a dimension that they could not have anticipated early in the process—the validation of their ideas and feelings by others. Through the exhibition, people were given the opportunity to exchange ideas, and to see how others interpreted their intentions.

You may not want to exhibit your work in this fashion, nor is it necessary in order to get satisfaction out of creating a self-portrayal. However, we do encourage you to share your ideas with others. Feedback from them will enhance your experience of the self-exploration process.

CHAPTER 11

Final
Reflections

The work that you have done in this book should not be viewed as a finished project, but rather as a starting point, a way of practicing for a life punctuated by frequent self-examination, whether serious or playful. But before you move forward on that journey, you may want to stop and think about what you have already learned. Whether or not you are fully aware of it, through the process of doing the exercises, you have already become a different person from who you were before.

In what ways have you changed? One answer is that you have been through a process of generating something new—writings, images, groupings of materials—that did not exist before. You have created something personal, something that has come from within you. You have brought into existence something based on ideas that hitherto existed only inside your head. Now you can look at it, touch it, show it to others, revisit it at some later date as a reminder, or use it as a comparison for the future. You have made a record that conveys your views about yourself and about your world.

Making your ideas tangible is a powerful thing. It is one thing to think about something in the abstract, but another to see your ideas made manifest. It may be surprising to see what you have come up with. Upon seeing what you have done, you may find yourself saying "I did that? I didn't realize how I was feeling or thinking until I saw my ideas on

paper." Take some time to reflect on what it was like to give concrete expression to something you were feeling or thinking. Did that expression help you understand yourself better? Did it teach you something about yourself you didn't already know? Did exploring yourself allow you to be creative in a playful way, even while at times confronting uncomfortable aspects of your life? Which exercises had the strongest impact for you and why?

Reflect on the process you used to create the examples for the exercises. Ask yourself how you approached the exercises and/or your self-portrayal. Did you run with the first ideas that came into your head? Did you ponder several ideas over time, weighing your approach to each question? Did you share your ideas with other people before executing a given exercise? Much can be learned from observing your own methodology. Your approach to creating something substantive from your ideas can say as much about you as the results themselves. Being mindful of your personal approach can help you navigate future situations. The question is not whether a given approach is good or bad, but whether it is serving you well. If you repeat any of the exercises from this book at a later date, you may want to think about approaching them differently to see if taking a new tack influences the outcome.

Perspective comes to all of us over time. Being able to look back at your responses to questions about the key issues of your life can be helpful in the future in assessing how your view of the world has changed. The more complex and busy our lives become, the harder it may be to recall exactly how we thought or felt in the past. Saving your responses to the exercises can also help you assess how your self-expression changes over time. Even as technology develops and our ways of creating and storing images and writings evolve, so too will our own methods for expressing ourselves. What lessons will you learn about expressing yourself? In what ways will you become more articulate? Are there new methods of self-expression that you want to explore and develop?

Listed below are some basic ways you can apply methods of self-expression on a regular basis as tools for self-exploration in your daily life.

Journaling

Start writing in a journal. You may write daily or weekly, or as the spirit moves you. You may write in the first or third person, or you may write to someone in particular. You may prefer to focus on factual details of your daily life, or you may be more interested in the emotional overtones of events. You may illustrate your journal with drawings or photographs. (If you wish to share such materials with others via the Internet, consider starting a blog using one of the many free blogging services, such as LiveJournal or Tumblr.)

Documentation

As an experiment, try keeping the evidence of everything that you do for the next month (ticket stubs, restaurant menus, wine labels, concert programs, maps of where you've visited, etc.). At the end of the month, look through the materials and write a story about each item—where you got it, what it means to you, and what that object says about your values and who you are. Get in the habit of dating all of your photographs and making hard copies to put into albums, or uploading your digital photos to a Web photo-sharing site. Digital photographs are wonderful, but not so easy to access if they are only stored on your camera or your computer, which are susceptible to being damaged or stolen.

Online contact

There are many social-networking websites (Facebook and MySpace are two current popular ones) which allow you to create your own personal profile. If you belong to any of these web forums, it might be fun to publish some of your work from this book as part of your profile, especially the self-portrait which you created in the previous chapter. If you are so inclined, you might consider starting an online "self-reflections" group.

Meetings with friends and family

Doing the exercises in this book together with friends can stimulate very interesting conversations. Try some of these exercises with family members, or share what you have already done with family members. You might make this part of family gatherings (anniversaries, reunions, holiday celebrations) or schedule a special occasion where you draw family members together to do some specific exercises. Cross-generational perspectives on issues like gender, values, and historical context are fascinating for all members of the family.

Develop new exercises

The topics and exercises we chose for this book are not exhaustive by any means. In fact, you may want to personalize the exercises to suit your own style, or reframe them to explore other subject matter. Consider doing this in collaboration with friends.

The adage "practice makes perfect" is usually applied to physical skills, memorization tasks, or other endeavors where repetition helps us to hone our abilities. Practice also plays a critical role in the realm of self-reflection. While we don't believe that human beings can attain perfection, we do believe that practice makes us more aware of who we are and what we are about. It is one thing to read through the exercises, and quite another thing to do them. We encourage you to work through all of the exercises in this book in a fashion that suits you best, not necessarily in chronological order. Certain exercises may feel less comfortable than others, but sometimes the work we shy away from is the work we most need to do. Try to be mindful of this on the occasions where an exercise seems particularly challenging, and assess why that may be so.

You can think of this book as a workbook, as a structured way for you to approach self-understanding through creative thinking and expression on a variety of topics. We have provided the structure, but you must provide the work. You may modify exercises if you would like to make them more personal. If you do, we hope you will continue to combine the use of photography, writing, and art. Using a variety of media will result in a richer, multi-dimensional exploration.

Life is not static. You are a different person today than you were yesterday or will be tomorrow. As we move through our lives, we don't always record what we are thinking, feeling, and doing, and we often don't find the time to make periodic assessments of where we have been and where we are headed. We encourage you to revisit some of the exercises in this book more than once, perhaps at yearly intervals or when something new happens in your life (the birth of a child, a new job, the beginning or end of a relationship). You may find yourself saying "Wow, look how my views have changed since I did this exercise five years ago!"

Although the book is designed primarily for the individual reader, we provide instructions throughout for doing the exercises with others. To get a full picture of our identities, we need to explore not only our own self-reflections but also the way others see us, which can provide additional feedback, motivation, and perspective. We have conducted many of the exercises at informal gatherings, both with our families and with our friends. The exercises served as a catalyst for conversation, and proved to be interesting ice-breakers at our parties and dinners. Participants often commented about the fun they had doing something creative as a group that helped them to get to know each other on a more personal level. Using the exercises as a focal point for everyone's attention gives all participants a common experience, and the opportunity to express themselves in a playful, personal way. If you are currently part of a social organization, you might consider using this book in your group. You could also start a "self-reflections" group in which you do one or more exercises from each chapter over a specified period of time. If you are a group facilitator or instructor, we have included an appendix with a set of instructions on using this book in a group setting.

A few parting thoughts: Keep it real, make it personal, apply what you learn. If your goal in reading this book has been to know and express yourself better, think of the work you have done as a tool you will continue to use once you put this book away. Be mindful of the things you most enjoyed learning. Be playful in your self-explorations. Try to be thoughtful about how you approach your life. Revisit your beliefs and be willing to reassess them over time. Self-awareness takes effort, but the rewards are rich. We hope you will use this book as a starting point. The rest is up to you.

A Guide for Instructors and Group Facilitators

In this appendix, we offer suggestions on how to teach a class based on *A Creative Guide to Exploring Your Life*. We also look at ways in which exercises in this book can be used as adjunct materials for classes on a variety of subjects. Finally, we have included some thoughts about how to use this book in college orientation programs.

1. Teaching a class on *A Creative Guide to Exploring Your Life*

Through our years of experience teaching this material at the college level, we have come to appreciate how important it is for people, particularly adolescents and young adults, to be able to explore their changing identities in thoughtful and creative ways. The reaction of students to our class has always been positive and underscores the value of this kind of self-exploration in a structured and supportive environment. As one student commented, "This seminar gave me the excuse to spend time on thinking about who I am. With all the pressure of problem sets and exams, I was able to justify taking time for myself which I found invaluable."

Class size and length of sessions

In our experience, the optimal size for a class on *A Creative Guide to Exploring Your Life* is approximately 12 participants. Twelve students can

be subdivided into pairs, trios, quartets, or two groups of six for variation in class format and interactions. Having more than 12 students makes it more difficult for people to get enough time to share in class. Having fewer than eight students decreases the chance of having lively discussions (especially if a few students are missing due to illness or other issues). If you have more than 12 participants, you might want to increase the time allotted for class sessions, or decrease the time frames if you have fewer than eight participants. A two hour weekly slot for the class seems to work well; it gives students time to do the weekly assignments and discuss them (or do them in class) without getting tired out.

Ground rules

In a class which asks students to examine personal experiences and to express them, it is important to set some basic ground rules. These include making it clear to everyone that this is an interactive class based on personal material and that students have the option not to reveal anything that they are not comfortable presenting in the context of a group. To make the environment safe for self-disclosure, students should be told not to disclose specific information about other people's stories outside of class. The importance of showing up regularly and on time out of respect for the group process should be stressed.

General structure of classes

We have found that it works best if we begin each class with an overview of the topic (which includes a brief discussion of the readings), followed by one or two in-class exercises that take up the majority of the two hours allotted for the seminar. Each class ends with students writing a short summary of what most affected them during class. We have found this written feedback gives us the opportunity to analyze the class as it is progressing, and to adjust pace, format, or content where necessary.

The first class

The first session of the class sets a tone for subsequent classes, so it is useful to begin with a minimum of teacher talk and go right into an

exercise. After brief introductions, we say a few words about the class and the ground rules, and then go directly into an exercise such as "Drawing my life" (Chapter 3, Exercise 1) or "Who am I today?" (Chapter 1, Exercise 1). Students particularly enjoyed creating a visual image of the one word that they chose to describe themselves. Some students have even suggested where on their bodies they might tattoo this image! These exercises serve as ice-breakers and also help create a group experience so that there is immediate common ground. This is especially important if the students don't know each other. We finish the first meeting by going over the logistics of the class. At this first session, we give each student a box (one with a lid, designed for organizing documents or photographs, works nicely) in which they will be able to store material from this class as well as mementos of their lives. We also supply a journal in which the students are encouraged to write on a daily basis. The box and journal are valuable since they are tangible, reinforcing the visual component of the class.

Mid-term assessments

Near the middle of the term, we meet with the students individually to go over the development of their end of term self-portrayals. In these meetings, the students are encouraged to discuss their ideas with family members and friends, and to ask for feedback and suggestions on their portrayals from other students in the class. The students are asked to generate titles for their presentations that will tie together what they are learning about themselves, and to write about what it is like for them to create their design. In class, students are divided into groups of three to discuss with each other the progress they are making on their self-portrayals.

End-of-term exhibition

At the end of the term, we schedule a college-wide exhibition of student work. We hold a reception where students discuss their self-portrayals (and some of the exercises done throughout the term) and share their insights and creativity with the public. Our students have said this is a valuable learning experience both personally and

academically. It validates student work in a way that does not always happen when assignments are only viewed by the instructors. It is also an excellent group bonding experience and gives students the chance to integrate the term's material in a meaningful way that expresses the ideas to a broader audience.

2. Using exercises as adjunct material in other classes

The exercises in the book can be used as adjunct material in a variety of classes where an experiential component is desired to encourage group interaction. The exercises are especially well suited for classes that are communication-intensive. These might include classes in writing, general psychology, sociology, psychology of gender, race and ethnicity, expressive arts therapy, English as a Second Language (ESL), and foreign languages. If you are teaching this material to a population other than adolescents or young adults, you might want to focus on the exercises most relevant to that group. You may also reorder the topics in a way that is most appropriate to your given constituency.

Each exercise can be adapted for a specific audience when used individually, or whole chapters may be used to focus on a particular subject area. For example, someone teaching a foreign language or ESL class could use exercises as a way of encouraging students to become proficient in another language using materials that have relevance to their lives. A class on expressive therapy could experiment with any of the exercises in the context of exploring the use of creative methods in psychotherapy. An instructor teaching developmental psychology could utilize exercises such as "Drawing my life" (Chapter 3, Exercise 1) and "How do I want to be remembered?" (Chapter 9, Exercise 3) as ways of having students take an experiential approach to exploring bookends to a full life. A class on the psychology of gender could use the exercises in Chapter 4 to give students the opportunity to learn about gender roles in a personal, creative, and reflective fashion. An instructor offering a class on race and ethnicity might try incorporating some of the exercises in Chapter 5 to help students explore their own stereotypes, cultural backgrounds, and family origins. Faculty who teach general history classes could include the exercises on "Visualizing yourself in historical context" and "One thing that changed my world"

(Chapter 6, Exercise 3) to give students a more personal spin on world history and to enliven group discussion.

We have listed some classes above which seem a natural fit with specific exercises in this book. However, we believe that much of the material in *A Creative Guide to Exploring Your Life* could be used in a wide variety of academic offerings. You may want to consider ways in which the class you are currently teaching could incorporate some of the exercises to make your own class more experiential.

3. Enriching orientation programs for college students

In light of the fact that many undergraduates experience a sense of alienation or loneliness, especially when they first arrive on campus, it is particularly important that students have a safe and structured place in which to engage with others on topics of importance in their lives. For many freshmen, the experience of coming to college can be the first time they are out of their "safety zone." Unfamiliar people, a more rigorous academic schedule and standards, and a new physical environment can create stress that feels overwhelming to students, especially without the support and structure their families and high schools have provided.

Many orientation programs include small interactive groups where students discuss the expectations and experiences of being in college. Such programs are valuable in helping students adjust to a new environment. We believe that integrating the creative methods developed in *A Creative Guide to Exploring Your Life* into these discussion groups can help students engage more deeply with each other and with themselves. Exploring topics such as roles, identity, families of origin, and gender and race using tools such as photography, drawing, and creative writing can lend a fresh perspective to self-disclosure. We have found that having new students introduce themselves to others through a visual autobiography, for example, allows them to explore and reveal material about who they are and where they came from in a novel and intriguing fashion. Our own students have consistently said that participating in creative exercises in a group context allowed them to delve into themselves more deeply. They described the experience as fun and helpful in making a connection to others.

We encourage orientation coordinators to incorporate *A Creative Guide to Exploring Your Life* into the programs for incoming students at their college or university. The book might be used in several ways. For example:

- Send copies of the book to incoming freshmen during the summer before they enter and have them do several of the exercises which they could then post online. During orientation, students would meet in small groups to discuss the examples already done.

- Provide copies of the book to orientation leaders and have the leaders run appropriate exercises from the book during the orientation period.

Since orientation usually ends after one week, offering ongoing seminars or workshops dedicated to self-exploration and self-expression seems particularly important. Regular group meetings that include reflective and creative exercises can help students cope with the changes they experience during their first term as they develop new friends, live with new roommates, struggle with tests and grades, and cope with a variety of pressures. Consider offering seminars or workshops that start during orientation and last throughout the term. These groups could be led by faculty, qualified upperclassmen, graduate students, or staff members, and would include students interested in further exploring the topics in the book (or perhaps a new set of topics) through self-expressive methods. They could be run as credit-bearing seminars (as we have done at our university) or as workshops offered weekly or periodically throughout the term. Whatever format you choose, the new students will be given a valuable opportunity to continue the process of self-exploration.

Creative and meaningful self-expression is particularly valuable in helping adolescents and young adults learn to find their way in the world as individuals with unique identities. Self-reflective habits which start or continue in college (such as writing in a journal, drawing, composing poetry, and exploring the value of one's friendships through photography and writing) can last a lifetime and can serve as guideposts in turbulent times.

Syllabus for a Class on *A Creative Guide to Exploring Your Life*

Week 1 Introduction

Introduction of instructors and students; discussion of class objectives.

Exercise 1: *Who am I today?* (Chapter 1)

Go over outline of syllabus, expectations of students, and requirements; go over outline of final project; discuss camera access; discuss when to have a class dinner and where to present the final projects exhibition; supply boxes and journals; distribute syllabus and course description

Reading assignments: Chapters 1 and 2 in *A Creative Guide to Exploring Your Life*

Week 2 The value of self-exploration and self-expression

Exercise 1: *Drawing my life* (Chapter 3)

Reading assignment: Chapter 3 in *A Creative Guide to Exploring Your Life*

Week 3 Turning points and key people

Exercise 1: *Key people* (Chapter 3)

Exercise 2: *Turning points* (Chapter 3)

Photo assignment: Have students bring in a family photograph

Photo and writing assignment: *Family tree* (Chapter 5)

Reading assignment: Chapter 10 in *A Creative Guide to Exploring Your Life*

Week 4 Family influences

Exercise 1: *Reflecting on family photos* (Chapter 3)
Exercise 2: Share students' family trees
Writing assignment: *Reverse gender autobiography* (Chapter 4)
Photo assignment: *Gendered photos* (Chapter 4)
Reading assignment: Chapter 4 in *A Creative Guide to Exploring Your Life*

Week 5 Gender and self

Exercise 1: Share students' reverse gender autobiographies
Exercise 2: Discuss students' gendered photos
Assignment: Bring to the next class a cultural object of personal value (*Cultural objects* exercise, Chapter 5)
Reading assignment: Chapter 5 in *A Creative Guide to Exploring Your Life*

Week 6 Race and ethnicity

Exercise 1: *Cultural objects* (Chapter 5)
Exercise 2: *Racial and ethnic stereotypes* (Chapter 5)
Photo and writing assignments: *Visualizing yourself in historical context* and *One thing that changed my world* (Chapter 6)
Reading assignment: Chapter 6 in *A Creative Guide to Exploring Your Life*

Week 7 Self in historical context

(During this week, instructors hold individual meetings with students to discuss self-portrayal projects)
Exercise 1: *Discuss Visualizing yourself in historical context* assignment

Exercise 2: Discuss *One thing that changed my world* assignment

Photo and writing assignments: *Expressing meaning through art and poetry* and *Friendship maps* (Chapter 7)

Reading assignment: Chapter 7 in *A Creative Guide to Exploring Your Life*

Week 8 Meaning in our lives

Exercise 1: Share students' friendship maps

Exercise 2: Share students' *Expressing meaning through art and poetry* assignments

Photo and writing assignment: *Alter ego* (Chapter 8)

Photo assignment: *Portraits without faces* (Chapter 8)

Reading assignment: Chapter 8 in *A Creative Guide to Exploring Your Life*

Week 9 Alternative views of self

Exercise 1: Discuss students' alter ego assignments

Exercise 2: *Portraits without faces* (Chapter 8)

Writing assignment: *How do I want to be remembered?* (Chapter 9)

Photo and writing assignment: *Fork in the road* (Chapter 9)

Reading assignment: Chapter 9 in *A Creative Guide to Exploring Your Life*

Week 10 Self in the future

Exercise 1: Discuss students' *How do I want to be remembered?* assignments

Exercise 2: Discuss students' *Fork in the road* assignments

Assignment: Design a half-hour exercise for following week

Assignment: Finish self-portrayals

Week 11 Presentation of self-portrayals

In-class presentations of portrayals

Students run half-hour exercise designed the previous
week

Week 12 Continuation of presentation of self-portrayals

In-class presentations of portrayals

Photo and writing assignment: *Evidence of meaning in my
life* (Chapter 7)

Reading assignment: Chapter 11 in *A Creative Guide to
Exploring Your Life*

Week 13 Final reflections

Exercise: Discuss students' *Evidence of meaning in my life*
assignments

Evaluation of class

References

American Heritage College Dictionary (2004) *American Heritage College Dictionary*, 4th ed. Boston: Houghton Mifflin.

Brown, L. and Gilligan, C. (1992) *Meeting at the Crossroads*. New York: Ballantine Books.

Bureau of the Census (2000) *Census of Population and Housing*. Washington, DC: US Department of Commerce, Economics and Statistics Administration, Bureau of the Census.

Erikson, E. (1963) *Childhood and Society*. New York: W.W. Norton and Company.

Frankl, V. (1959) *Man's Search for Meaning*. Boston, MA: Beacon Press.

Jung, C.J. (1970) *The Structure and Dynamics of the Psyche*. Princeton, NJ: Princeton University Press.

Pennebaker, J. (1990) *Opening Up: The Healing Power of Expressing Emotions*. New York: Guilford Press.

Pollack, W. (2006) *Real Boys: Rescuing Our Sons from the Myths of Boyhood*. New York: Henry Holt and Company.

Rother, L. (2003) "Racial quotas in Brazil touch off fierce debate." *New York Times*, 5 April.

Further Reading

Alinder, J. (ed.) (1978) *Self-Portrayal*. Carmel, CA: The Friends of Photography.

Bridges, W. (1980) *Transitions: Making Sense of Life's Changes*. Reading, MA: Addison-Wesley Publishing Company.

Carey, B. (2007) "This is your life (and how you tell it)." *New York Times*, 22 May.

Daniel, L. (1997) *How to Write Your Own Life Story*. Chicago, IL: Chicago Review Press.

Elliott, A. (2001) *Concepts of the Self*. Malden, MA: Blackwell Publishers.

Hieb, M. (2005) *Inner Journeying through Art-Journaling*. Philadelphia, PA: Jessica Kingsley Publishers.

Lafo, R., Weiss, F., and Fifield, G. (2004) *Self-Evidence: Identity in Contemporary Art*. Lincoln, MA: Decordova Museum.

Langer, E. (2005) *On Becoming an Artist: Reinventing Yourself through Mindful Creativity*. New York: Ballantine Books.

Pennebaker, J. (2004) *Writing to Heal*. Oakland, CA: New Harbinger Publications.

Rainer, T. (1997) *Your Life as Story*. New York: Jeremy Tarcher.

Rich, P. and Copans, S. (1988) *The Healing Journey: Your Journal of Self-Discovery*. New York: John Wiley and Sons.

Rogers, C. (1961) *On Becoming a Person*. Boston, MA: Houghton Publishing.

Roorbach, B. (1998) *Writing Life Stories*. Cincinnati, OH: Story Press.

Sweet, H. (2006) "Composing your life: Exploration of self through visual art and writing." Unpublished paper presented at the annual conference of the American Psychological Association, New Orleans, LA.

Thomas, F. (1984) *How to Write the Story of Your Life*. Cincinnati, OH: Writer's Digest Books.

Weiser, J. (1999) *PhotoTherapy Techniques*. Vancouver, Canada: PhotoTherapy Centre.

Weissman, N. and Heimerdinger, D. (1979) *Self-Exposure: A Workbook in Photographic Self-Portraiture*. New York: Harper and Row.

Zimmerman, S. (2002) *Writing to Heal the Soul*. New York: Three Rivers Press.

Index

Alter ego (exercise) 132–3
alternative views of self
 exercises 129–30, 132–3,
 139
 exploring 142–3
 and the shadow self
 127–8
 and societal expectations
 128
authority figures 39
autobiography
 exercises 40–1, 67–8
 importance of 39

Brazil 78
Brown, Lyn 61

college orientation programs
 181–2
Composing Your Life 9
Cultural objects (exercise)
 84–5
culture
 exercises 84–5
 and gender 61

digital camera 15
documentation 32–3, 174
 checklist for 35–6
drawing
 exercises 40–1

Drawing my life (exercise)
 40–1

Erikson, Erik 112
ethnicity
 definition of 77–8
 exercises 79–80, 84–5,
 86–7
 and objects 93–4
 stereotypes 78–9, 86–7
 see also race
Evidence of meaning in my
 life (exercise) 113
exercises
 alternative views of self
 129–30, 132–3,
 139
 autobiography 40–1
 culture 84–5
 developing new 175–6
 encouraging group
 interaction 180–1
 ethnicity 79–80, 84–5,
 86–7
 family 51–3
 friends 123–4
 future and the self
 146–7, 149–50,
 154–5
 gender 62–3, 67–8,
 70–1

history 96–8, 100–1,
 104–5
 key people 44
 meaning in life 113, 116,
 119–20
 photography 51–3
 race 79–80, 86–7
 self-exploration 22–6
 self-expression 35–6
 self-portrayal 164–5
 turning points 40–1, 49
Expressing meaning through
 art and poetry (exercise)
 116

family
 exercises 51–3
 influence of 39–40
 meetings with 175
 photographs of 30–1, 33
Family tree (exercise) 79–80
Fork in the road: Where do I
 want to go from here?
 (exercise) 149–50
Frankl, Viktor 111
friends
 exercises 123–4
 importance of 39
 meetings with 175
Friendship maps (exercise)
 123–4

future and the self
 exercises 146–7, 149–50,
 154–5
 visualizing 144–5, 158–9

gender
 and culture 61
 exercises 62–3, 67–8,
 70–1
 norms 60–2, 74–6
Gender stereotypes (exercise)
 70–1
Gendered photos (exercise)
 62–3
Gilligan, Carol 61
group facilitators see
 instructors
group interaction 180–1

history
 exercises 96–8, 100–1,
 104–5
 and self-exploration 95–6,
 109–10
How do I want to be
 remembered? (exercise)
 154–5

images
 exercises 40–1
 power of 29–30
instructors
 class size 177–8
 end-of-term 179–80
 first class 178–9
 ground rules 178
 length of session 178
 mid-term 179
 structure of classes 178
Insurance inventory of valued
 items (exercise) 119–20

journaling 18, 31–2, 34, 174
Jung, Carl 127

Key people (exercise) 44

key people, influence of
 authority figures 39
 exercises 44
 family 39–40
 friends 39–40
 understanding 58–9

Man's Search for Meaning
 (Frankl) 111
Massachusetts Institute of
 Technology (MIT)
 Composing Your Life 9
 MIT Experimental Study
 Group 9
meaning
 areas of 111–12
 changes in 112–13
 definition of 111
 exercises 113, 116,
 119–20
 and photography 116,
 126
 and wealth 112
meditation 18
Meeting at the Crossroads
 (Brown and
 Gilligan) 61
men and boys
 norms of 60–2, 74–6
observing ego 19
One thing that changed my
 world (exercise) 104–5
orientation programs, college
 181–2

Pennebaker, James 31
photography
 exercises 51–3
 family 30–1
 meaning in 31
 meaning in life 116,
 126
 and psychology 33–4
 reviewing 22
 and roles 30
 and self-exploration 21–2

and self-expression 28,
 29–31, 34–5
poetry
 and meaning in life 116
Pollack, William 60, 61
Portraits without faces
 (exercise) 129–30
portrayal of self 10
psychology
 and self-exploration 20–1
 and self-expression 33–4
psychotherapy
 and the observing ego 19
 and self-exploration 18, 19

race
 definition of 77–8
 exercises 79–80, 86–7
 and objects 93–4
 stereotypes 78–9, 86–7
 see also ethnicity
Racial and ethnic stereotypes
 (exercise) 86–7
Real Boys (Pollack) 60
reflections
 process of 172–3
retreats 18
Reverse gender
 autobiography
 (exercise) 67–8, 75
roles
 and gender 60–2, 74–6
 and photography 30
 and self-exploration 20,
 26
 and self-expression 30
Roles I play (exercise) 26
Rother, L. 78

self-exploration
 definition of 18
 exercises 22–6
 forms of 18
 and history 95–6,
 109–10
 need for 17–18, 19–20

and photography 21–2
and psychology 20–1
and roles 20, 26
and self-expression 28–9
self-expression
 definition of 28
 documentation 32–3, 174
 exercises 35–6
 function of 36–7
 journaling 174
 and photography 28,
 29–31, 34–5
 and psychology 33–4
 and self-exploration 28–9
 social-networking
 websites 174
 and writing 28, 31–2
self-portrayal
 audience for 161
 beginning 161–2
 designing 162–4
 exercises 164–5
 in group context 165,
 171
 reasons for 160–1
shadow self 127–8
social-networking websites
 174
stability of self 19–20
supplies 15
Switching places (exercise)
 100–1
syllabus 183–5

The future is now—a comic
 strip (exercise) 146–7
turning points
 definition of 38–9
 exercises 40–1, 49
 understanding 58–9
Turning points (exercise) 49

United States of America 78
Unmasking the self (exercise)
 139

Visualizing yourself in
 historical context
 (exercise) 96–8

Who am I today? (exercise)
 23
women and girls
 norms of 60–2, 74–6
writing
 forms of 31
 journaling 18, 31–2, 34
 and psychology 33–4
 and self-expression 28,
 31–2

CPSIA information can be obtained at www.ICGtesting.com
Printed in the USA
BVOW08s1121300713

327127BV00003B/9/P